Jonathan Lerman

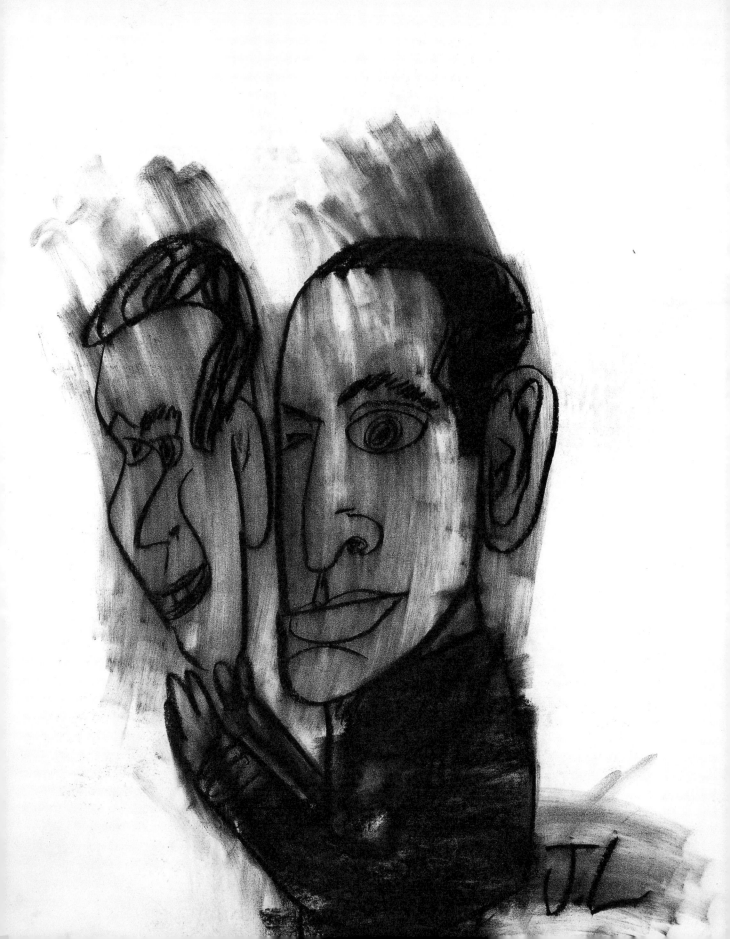

Jonathan Lerman

Drawings by an Artist with Autism

with texts by Lyle Rexer

George Braziller New York

The author wishes to acknowledge the significant contribution of Kerry Schuss
to the appreciation and understanding of Jonathan Lerman's work.

For information, please address the publisher:
George Braziller, Inc.
171 Madison Avenue
New York, NY 10016

Design by Binocular, New York
Printed and bound in Singapore by Tien Wah Press
First edition

Frontispiece: 2002 24 × 19 in.

Library of Congress Cataloging-in-Publication Data
Lerman, Jonathan.
 Jonathan Lerman : drawings by an artist with autism / with texts by Lyle
Rexer.—1st ed.
 p. cm.
 ISBN 0-8076-1513-7
 1. Lerman, Jonathan—Themes, motives. 2. Artists with mental disabilities—
United States. 3. Savants (Savant syndrome). 4. Autistic children. I. Rexer,
Lyle. II. Title.

NC139.L462 A4 2002
741.973—dc21

 2002074651

Contents

Jonathan Lerman: What the Hand Sees

Lyle Rexer

"Anyone who renders his creative drive directly and genuinely is one of us." —Ernst Ludwig Kirchner et al., manifesto of the group *Die Brücke*[1]

As Caren Lerman tells the story, her son Jonathan, diagnosed with autism, was at school when she received a phone call. She had learned to dread such calls, especially from the school, because they inevitably signaled a social catastrophe of some kind, more evidence of Jonathan's inability to negotiate the world around him. But this call was different. "You have to come down here and see what Jonathan is doing," said the teacher. "He's drawing!"

Because Jonathan Lerman has great difficulty communicating verbally, we will probably never learn what triggered the first impulse to generate form, or what inspires him today to work as he does, often at breakneck speed. But embodied in his drawings is the trajectory of a gifted graphic artist. That trajectory is so steep, the development so compressed, it is possible to overlook it, to assume that his ability sprang full blown. The actual sequence is profoundly different and contradicts the stereotype of the genius, the prodigy, the almost inhuman creative "other." I believe the work is bound up with who Jonathan Lerman is and who he is becoming. The teacher might just as well have shouted, "He's being born!"

1. Ernst Ludwig Kirchner et al., "*Die Brücke* Program," in *German Expressionism: Documents from the End of the Wilhelmine Empire to the Rise of National Socialism* (New York: G. K. Hall, 1993), 23.

Lerman began not with primitive representations—stick figures or cartoons—but with developed fragments, usually of faces. Noses, a single eye framed in a square, incomplete assemblages float on the page without regard to each other. They recall the preparatory studies artists make in their notebooks, the most famous being Leonardo da Vinci's sketches of hands. They remind us, too, of the associative fields of Surrealist imagery, especially Joan Miró's, fields of combinatory possibilities. Miró's are psychic spaces, without clocks or compositional rules, where forms arise and dance and inner necessity is obliged.

Lerman assembles a visual world in order to grasp how it hangs together and what it feels like to bring it into being. For him, pictures seem to be a matter of both thinking and feeling. In contrast to some current theories about people with autism, I believe that Lerman does intuit meaning in his images and that this intuition appears in his later work. Art becomes an interpretive process.

In any case, almost instantly a feedback loop seems to have formed, and Lerman's hand impelled him simultaneously toward seeing and knowing. Raw, crudely proportioned, Lerman's early portraits have the look and feel of "outsider" art—sudden and extreme, unable to organize the energy they tap. Bodies are unimportant and space is unexploited. Once Lerman's loop closed, however, the boy's hand moved on rapidly and learned to see. He mastered signature stereotypical elements—almond eyes, flat fleur-de-lis noses, conch-shell ears—

and organized them into distinct visages, magically, like making Mona Lisas from a Mr. Potato Head toy kit. One of the great pleasures of this work is that we are taken backstage, so to speak, to see how pictures come together as wholes greater than the sum of their parts.

The curiosity of Lerman's hand was never tentative, its discoveries always essential. So his art is suspended between childhood perception—all people look kind of odd, don't they?—and adult awareness—the outside of a person tells about the inside. Yet he always keeps ahead of himself because his hand follows "an active line on a walk, moving freely," as Paul Klee wrote.[2] Klee had to work to retain the spidery joy of his earliest childhood drawings. He practiced deliberate simplifications and strove mightily to achieve his loose, ambulatory sequences. Miro, Matisse, and Picasso trusted the body, and it never failed them; it led them through every maze, as it leads Lerman.

The painter Gerhard Richter once made the remark that he envied the art of Henri Matisse and Francisco de Goya because they had earned—or given themselves—permission to express themselves without restriction.[3] It was precisely this sense of permission that artists at the time of Matisse were seeking, and finding, in figure drawing, or "gestural drawing," as it was called. Their inspiration was Auguste Rodin, who developed the practice of drawing without lifting the pencil from the paper. His method soon became a common teaching strategy, but for Rodin it was clearly a form of possession, in which he

2. Paul Klee, *Pedagogical Sketchbook* (New York: Frederick A. Praeger, 1953), 16.
3. Interview with Gerhard Richter by Robert Storr, in Robert Storr, *Gerhard Richter: 40 Years of Painting* (New York: Museum of Modern Art, 2002), 308.

traced the outline of his models with his hand, using the pencil or crayon as an instrument of caress.

By that time—the beginning of the twentieth century—the drawing had played a variety of roles in Western art. It served as preparation for painting and sculpture, aesthetic snapshot and diary, academic study, finished work, political weapon. The avant-garde artists proposed a more significant role for the hand's work. Sensing that any drawing recapitulates the primordial act of representation, linked at once to unconscious motivations and to a magic summoning of form, they used drawing to overturn conventional fine-art hierarchies and achieve a more direct and personal visual vocabulary. As the art historian Patricia Gray Berman has noted, "Disclosing the changing trajectory of the artist's hand, these works are understood to be the subjective traces of the artists themselves."[4] How this subjective force led, on the one hand, to the automatic drawing of the Surrealists with offshoots in American Abstraction and, on the other hand, to a geometric Futurism is another story, but the two traditions share the process of drawing purified to its essential elements—in Matisse's words, "a means deliberately simplified so as to give simplicity and spontaneity to the expression."[5]

We evoke this historical situation not to pretend that Jonathan Lerman somehow participates in a drawing tradition he has never engaged, although he has copied work by Picasso and Matisse with panache. Rather, these artists unveiled a potential for drawing that enables us to appreciate Lerman's work more fully. The artist becomes a kind of medium through which energy flows and is transformed. Call Lerman's impetuosity childlike or erotic, it is what has marked artists since they drew bison in the caves of Lascaux and Altamira. To quote Matisse again, "There is nothing foreseen about my path: I am led. I do not lead."[6] Lerman's enjoyment of this primordial pleasure is different from Matisse's because it is unearned. Lerman begins without constraint. He only has to learn by doing. What he doesn't learn doesn't interest him. He reminds us of another very different self-taught artist, Bill Traylor. Traylor always starts right in wherever he finds himself, usually toward the center of the page, and then draws himself into corners, only to leap out of them through some magic escape hatch—a flattened hat, a shortened arm, a crooked roof.

In a brief time, Jonathan Lerman's sense of the face as the central expressive ensemble has gained certainty. Energy focused by his prescient hand needs only the simplest of means to evoke a woman's brassy disapproval, children's attitudes, a man's reticent introspection. These are things a child would not understand but could certainly register. Yet most children could not begin to render them; they are too transient. This evocative power is easiest to see in his pictures of familiar figures, Bob Dylan and John Lennon, for example. It makes little difference that his inspirations are images and not living subjects. He has them down. Lerman's economy, assurance, and penchant for tactical exaggeration link

4. Patricia Gray Berman, *Modern Hieroglyphs: Gestural Drawing and the European Vanguard 1900–1918* (Wellesley, Mass.: Davis Museum and Cultural Center, 1995), 14.
5. Ibid., 38.

6. Ibid., 43.

him to caricaturists and cartoonists but also to the organic understanding of Francis Bacon, without the horror and shame.

There are aspects of reality that Lerman's line has assimilated only gradually—bodies, especially, and hands almost not at all. No wonder Leonardo did so much doodling. Lerman at first engaged only faces, with typical elements that could be mastered and recombined to create distinguishing effects. The bodies in his early drawings look like afterthoughts, vestigial extensions of the head and face. People with autism are known to focus on faces, and this may well be how people appeared to him. More likely it reflects what was most prominent to his awareness. Hands and bodies need not be reckoned with, but faces, visually complicated, physically mobile, often puzzling in their language and expression, compel a response. As with the early drawings, Lerman has continued to extend his visual world by hand. This includes not only perspectival alterations but also striking postures and groupings. He has populated his world with characters, attitudes, words, symbols, even vignette-like episodes. While he initially depended on the immediate visual stimulus and accepted its limits, he now imports freely and uses familiar elements. If it feels good, it is good, and it belongs. If Lerman has earned a freedom, it may be the freedom actually to play.

OUTSIDE THE LINES

Based on their linear style, Jonathan Lerman's drawings cannot be mistaken for anyone else's. But the line is only one aspect of the intentionality in the work, perhaps not even the most important one. The line launches the artist into the void of the paper surface and leaves in its wake something where there was nothing. But what is that something? In Lerman's case, it is not yet an expression of being until it is blurred.

Unlike the obsessive neatness and precision of drawings and paintings by many people with autism— the careful, colorful architecture of Jessy Park's paintings comes to mind—Lerman's pictures are a wild mess. The figures are smudged and blurred in what appears at first as a crude attempt at shading. He certainly doesn't bother trying to color inside the lines. Yet the blurring follows an unerring visual logic. Its flurries suddenly cease in order to allow the whiteness of the paper to show through at exactly the points where light would reflect off a forehead, cheek, or an eye. The pattern of blurring and clarity tells us how to read the drawings. In spite of their rapid composition, the drawings actually involve a multistep process, a harnessing of different energies in different motions. All are necessary to bring the picture into being.

Lerman smudges some areas first, as a way of blocking, then draws over them, then returns to smudge again and draw again. Blurring crosses the line's

direction and qualifies its impetuosity but also amplifies its presence. Under the pressure of Lerman's smudges, dark areas—a woman's hat or a man's hair—become so black they threaten to suck the rest of drawing in. The effect is reminiscent of Odilon Redon or the black centers of Lee Bontecou's prints. The difference is that in Lerman's drawings, black does not carry metaphysical or psychological overtones. It anchors the picture and tells the eye where to look. There is a remarkable range of tones in these drawings, and Lerman knows exactly how to employ them. Blurring substitutes depth and dimension for speed and immediacy, insight for sight. It doesn't matter that the blurring runs beyond the lines. The figure is there, and the modeling actualizes and stabilizes it.

The more we observe these drawings, the more we become aware of the many decisions that go into making them. The apparent spontaneity should not blind us to this basic fact. When Rodin and Matisse set out to achieve a new directness in drawing, they very quickly found that they had to free not only their hands but their minds as well. Rodin often revised his "spontaneous" drawings in a process of recension and retraction. Lerman, too, revises his lines to achieve the effects he wants. Unlike most artists in the process of drafting, he does not have to make continuous contact with a model. He has the picture in his head, and he knows how he wants it to look. When Kerry Schuss, the artist and dealer who exhibits Lerman's work, first heard about the drawings, his initial advice to Caren Lerman was, "Just let the kid draw." When he saw the work, however, it was precisely the evidence of artistic decision making that convinced him he was dealing with the process of expressive maturation.[7]

PRODIGY INTO ARTIST

"There are no prodigies in art." —Pablo Picasso[8]

Picasso's declaration stands as a challenge to our appreciation of the work of Jonathan Lerman and of many others whose artistic gifts are bound up with psychic deficits or "abnormalities," especially so-called savants. Picasso might have meant his statement in two ways. First, because the gift of art making comes unbidden and has no season, it makes no logical sense to apply the word *prodigy*, which is merely a synonym for *premature*. More likely, Picasso meant that art arises not from ability but from desire shaped by consciousness. Its origins are not exclusively visual. For there to be art, there must be an artist engaged with his or her inner experience in the pursuit of formal understanding. Picasso knew what he was talking about, having been the closest thing in modern art to a prodigy himself. The prodigy is selfless, the victim of whatever subject seizes him, prisoner of his own aptitude. So Picasso might well have called Lerman a prodigy and questioned whether his evocations are merely uncanny—circumstantial, unaware, possessed. This is another way of asking, "Can there be art without an artist?"

7. Ralph Blumenthal, "Success at 14, Despite Autism," *New York Times*, Januray 16, 2002, p. E1.
8. Quoted in Oliver Sacks, *An Anthropologist on Mars* (New.York: Alfred A. Knopf, 1995), 195, n.

The answer is no. Where there is art, there must be an artist. But what makes an artist? Jonathan Lerman leads us to a more comprehensive answer.

The art of so-called savants—people with autism or the related Asperger's syndrome—continues to fascinate precisely because of the magnificent narrowness of their talent. Neuroimaging studies have suggested that entire areas of the brain of people with autism are virtually dormant while activity is channeled into limited domains. This description dovetails neatly with popular opinion, which sees art primarily as the ability to render the visible conventional world; never mind that the more "accurate" a work appears, the more calculated and convention-bound is likely to be its composition. Pictures by Nadia or Stephen Wiltshire, to take two famous examples of savants, appear to be the epitome of "genius." These legendary rendering machines were capable from early youth of recycling the seen world with a fidelity that defies explanation. At age three, Nadia could render a horse of such perfection that her drawing would have made Eugene Delacroix envious. Wiltshire reproduced most of London's landmarks by the age of ten. Their talents arose mysteriously complete, an ironic restitution for their autistic isolation, the discrepancy between life and art a cosmic joke. As neurologist and author Oliver Sacks has pointed out, the representations of such prodigies tend to be supremely literal, enslaved by the world, utterly dependent on a subject, whether presented to the eye or held in the mind's eye.[9] I am reminded of one such artist whose work I encountered,

the grandson of a world-renowned mathematician. He painted from memory the same tree in a forest, over and over, with only slight variations. The variations arose from his memory of walking toward the tree. Each step meant a change of place, a change of circumstances, an absolute change of being—hence, a new tree, a new forest, and the compulsion to render it again.

Savants also tend to be visual; that is, they think almost exclusively in pictures, unmediated by language, as the agricultural engineer and animal scientist Temple Grandin (herself autistic) has pointed out. So the deflections and slow modifications of ability worked by the subconscious, the continuous breaking down of conventions and of one's own previous work and building it back up, a process both visual and verbal, which we might call "imagination," never takes place. Instead, Sacks has argued, savant artists engage in a kind of formal play, a mere redistribution of elements, without cumulative intention or growing awareness of their work's evolution.[10] His argument is persuasive, yet some autistic work, especially Lerman's, does not fit this pattern. Moreover, the limitations of autistic production do not prima facie disqualify the works' reception as art. Indeed, the production of autistic artists can significantly deepen our understanding of art's possibilities beyond Sacks' category.

Jonathan Lerman's work challenges Picasso and denies the bondage of this artist-savant to a reality he cannot ignore, control, or fully interpret. Lerman's talent did not arrive, it evolved, albeit rapidly. His abilities and

9. Ibid., 206.

10. Ibid., 288–89, n.

the visual complexity of his work have grown with an expanding consciousness of the world around him—from parts to faces to bodies in space to men and women in relation. How much symbolic or psychological importance he attaches to these images is, I believe, an open question. By the same token, the images he produces seem not so much denotative as constitutive. They do not "capture" reality so much as confer it, conjuring up physical and emotional presences. Confronted by his impatient virtuosity, I cannot help feeling that Lerman's subjects are not fully experienced, not real, until he draws them. Plato said that only fools and children are taken in by representations, but for Jonathan Lerman, the world doesn't come first, art second. Art and world arise together in the energy of a moving, prescient line.

In our day, art suffers from a belatedness. It has long since surrendered power and necessity in exchange for freedom: the freedom to deviate from conventional and familiar forms, the freedom to become personal and individual, the freedom to be art and to criticize that very freedom. Art is valued above all for its conceptions, which include reflecting on itself, its situation, and its past. Such a definition is recent and incomplete. Detached from their maker—imagine you do not know anything about the artist—unhinged from discussions of style or influence, Lerman's drawings stand as objects to be reckoned with because they give evidence of a particular state of being. It is up to us to appreciate that state, recognize its contours and limits, and determine how it might reflect on our own situations.

I AND OTHERS

Behind the questions asked by Sacks as a medical professional and art aficionado lies a broader one of selfhood or its absence. Do autistic artists have selves that their art expresses? As physicist Freeman Dyson remarked about Jessy Park, "Her universe is radically different from mine. . . . Because these are people whose intelligence is intact, but something at the center is missing."[11] Artists whose intelligible verbal communication is severely limited face deep-seated assumptions about their nonbeing, even by other artists. Regardless of their actual psychological circumstances or living situations—whether they reside in families, in tenuous independence, or under the (often blind) eye of the state—they are seen to lack selfhood's elements: affect, continuity, symbolic recognition, expressiveness. Thus even the most beautiful, self-sufficient works of these artists, of Martin Ramirez, for example, or Adolf Wölfli, Dwight Mackintosh (another autistic artist), or the artists of Haus der Künstler (part of the Lower Austrian Psychiatric Hospital in Gugging, near Vienna), can be dismissed as postcards from Flatland, where life is always the same, always relentlessly particular, unnuanced and inaccessible.

Jonathan Lerman's artistic evolution—growth, really—shows me that the self, the being that

11. Ibid., 229–30, n.

communicates *how it is*—can exist in many states and degrees of cohesion, and each is potentially affirmed by art. Lerman is especially fascinated by his own initials and signature, incorporating them into his work in wonderful ways. He will run his full name along the contour of a portrait or use his initials, sometimes encircled with a flourish, almost as a logo. What is the exact nature of this fascination? How far can it be interpreted? People with autism are often fixated on the visual and patterned aspects of language. Does he know what his name "represents"? I think this, too, is a open question and perhaps an evolving one. In any case, his visual use of his name can impel us to look again at the signature as an element of art, to see, for example, that the signature in modern painting often acts as an essential component of the work. On the one hand, it separates the work from tradition, and on the other it presents a metonymy, a part that stylistically can stand in for the whole. It announces that style is more important than content because it makes the content cohere. If Lerman's work can provoke this awareness, do we need to specify the exact degree of the artist's "selfhood"?

Think of the self as a second skin or a suit you cannot take off. It might be tattered, missing parts, rumpled, mis-sewn. And it does not necessarily stay the same. Seams can open up, tears miraculously close. I am not convinced, as Freeman Dyson is, that in the case of people with autism the suit is empty. It is not essential that a work of art originate as an act of communication affirming the existence of other minds. It needs only to exist as the ordered product of an intention. Art need not meet any requirement except that it embody an awareness of this habitation within an I, however tentative that I.

Psychologists and neurologists may tell us what makes an I. They may outline what they think is the pattern for the suit, but art reveals that nobody, really, wears one cut from that pattern. And it is the very difference of the patterns that reaffirms the value of art as a replenishment of the world. What Clara Claiborne Park has written about her daughter Jessy could be applied to the appreciation of the art made by people with autism: "But those who have lived with Jessy know that the truest respect lies not in the wishful insistence that she is really just like other people, but in the recognition, and valuing, of what she is."[12]

12. Clara Claiborne Park, *Exiting Nirvana: A Daughter's Life with Autism* (Boston: Little Brown, 2001), 204.

Earliest Drawings

Lerman's early drawings bear the marks of an unconscious assembling process that Surrealists would have celebrated. A nose just might collide wonderfully with an eye. A mouth and nose might float toward you out of nowhere, almost off the sheet. These are studies and of a very particular kind. In them, a hand is practicing how to connect a mind to a world via the faces of other.

In these drawings Lerman is not interested in achieving fidelity to a model. And he is certainly not interested in symbolic meaning, that is, the sense that behind the image his hand assembles resides something that no image can fully disclose. The purpose of these early drawings is not accuracy but immediacy, differentiation, and recognition. What he sees is what we get. LR

1. 1997 9 × 12 in.

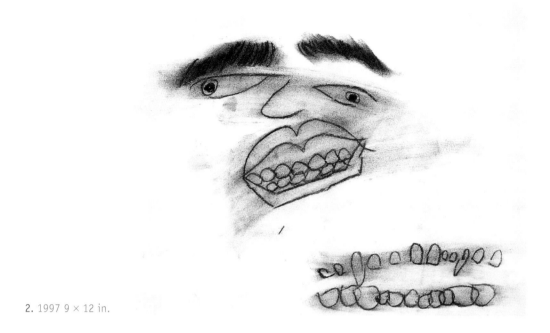

2. 1997 9 × 12 in.

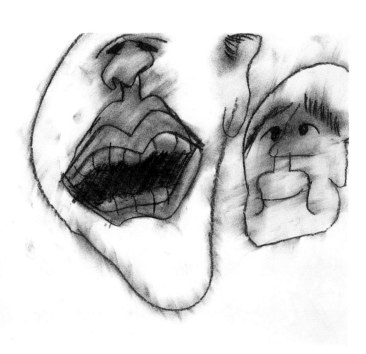

3. 1997 9 × 12 in.

4. 1997 9 × 12 in.

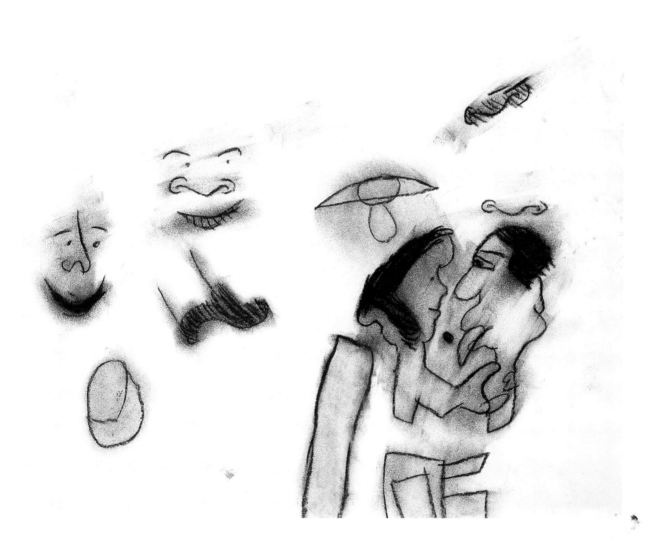

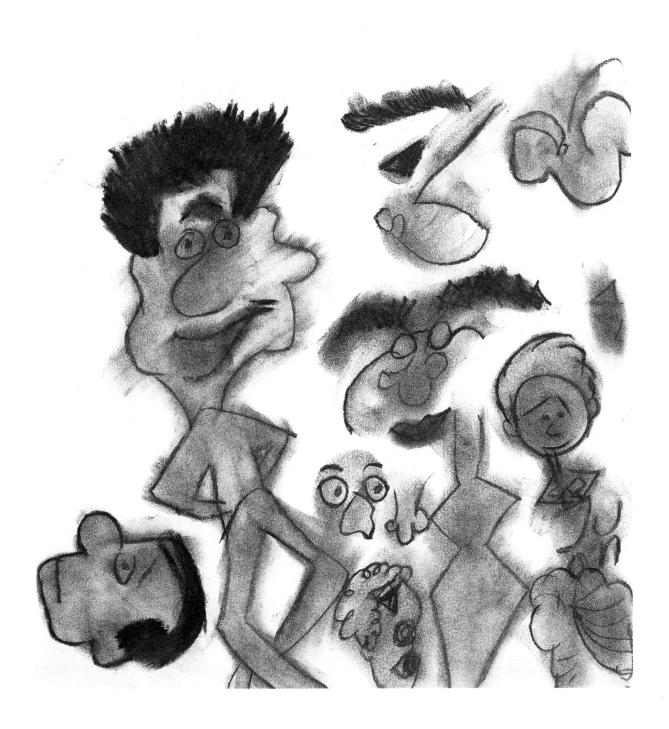

5. 1997 12 × 9 in.

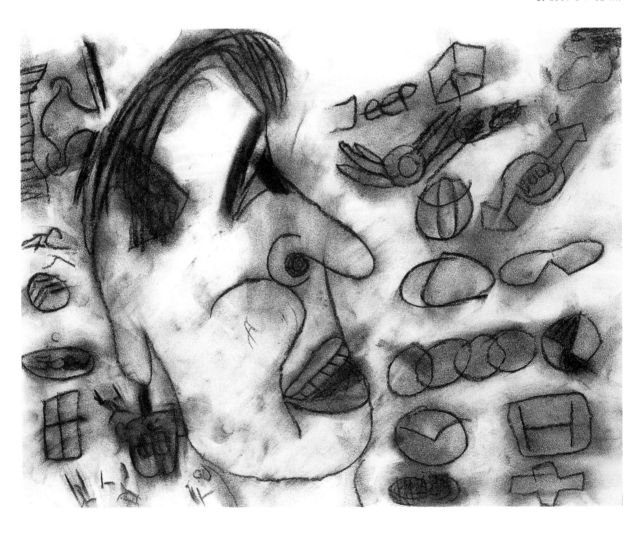

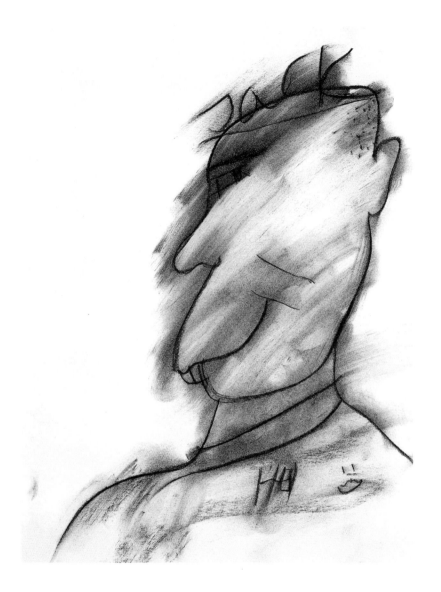

7. 1997 12 × 9 in.

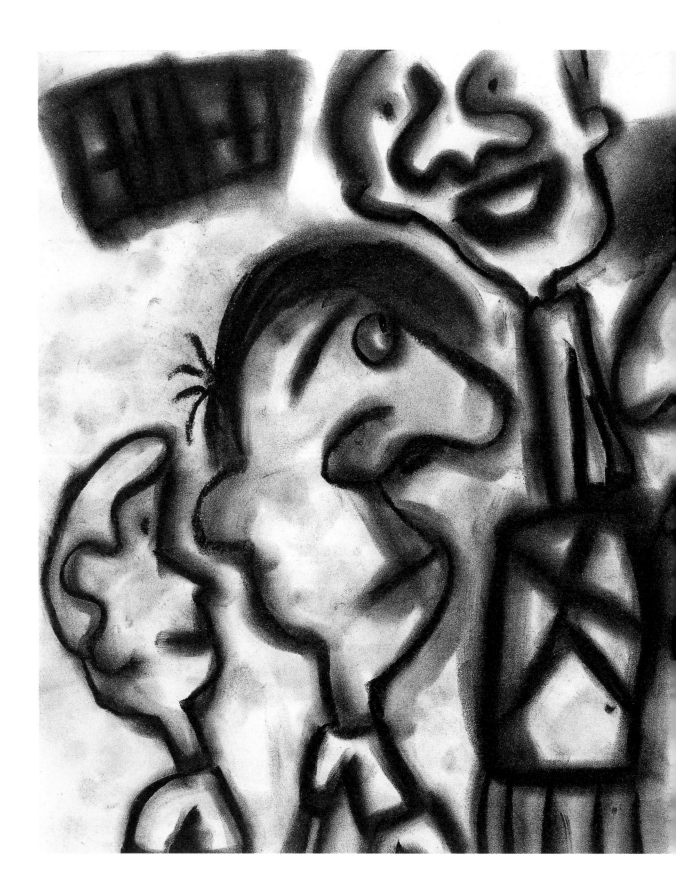

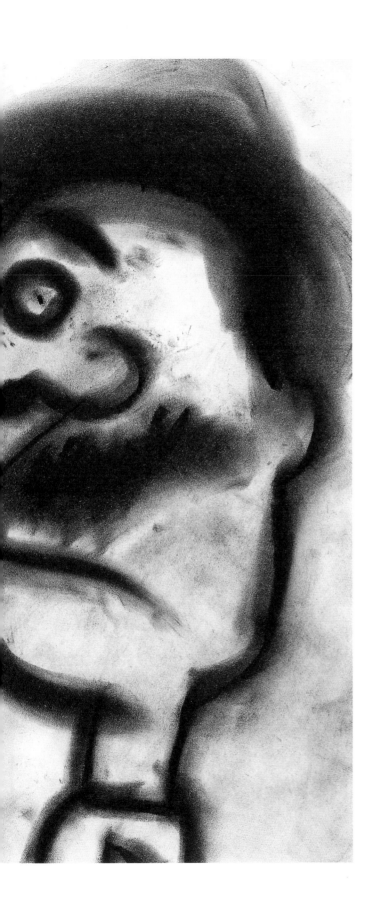

8. 1997 9 × 12 in.

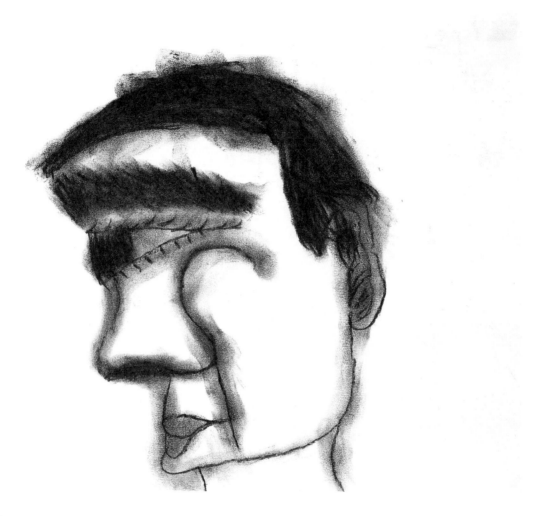

9. 1997 9 × 12 in.

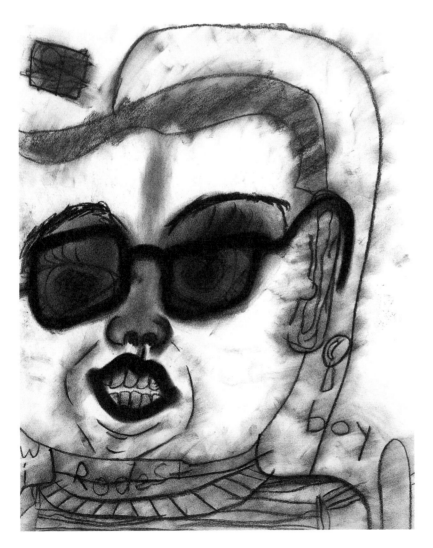

11. 1998 11 × 14 in.

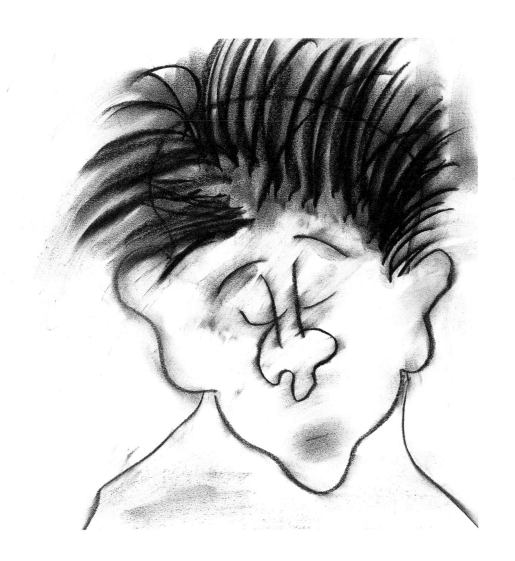

Portraits from the Outside

Since he began drawing, Jonathan Lerman has focused most of his artistic energy on the human face. The face identifies human beings as same-and-different. The face discloses the evidence of selfhood and consciousness. The face has eyes, in which we first recognize the possibility that we exist. The face, especially the mouth, is also the source of mysterious words and incomprehensible signs of emotion, ephemeral but perhaps disclosing some essence, too. In a fully socialized consciousness, a face may be a concealing mask, but for Lerman it is more like a name written on water. His attentiveness to the face may be part of his attempt to account for the consciousness he inhabits, an accounting carried out through representation of other faces. His hand is impetuous because without its work there is no assembling of parts into wholes and aspects into visages.

Our attention is drawn first to the eyes of these portraits, almost as if nothing else existed. Like the eyes of Picasso's portrait of Gertrude Stein, these are distinctly un-individual almonds. They could have been copied from a learn-to-draw course. Lerman situates them in the face, narrows one and widens another, darkens the pupil and adds shading for depth, begins the curve of a nose, and suddenly the face is transformed into something distinctive, often with a subtly angled orientation. The eyes crown an artist's sensitivity to physical presence that seems equally engaged by real subjects and photographs. It enables Lerman to invest his subjects with a nearness they never possess in their photograph incarnations.

The artist's hand creates a face. The face looks back and says, "We are. Are you?" With every face, the world and the artist are simultaneously confirmed. LR

12. 1999 17 × 14 in.

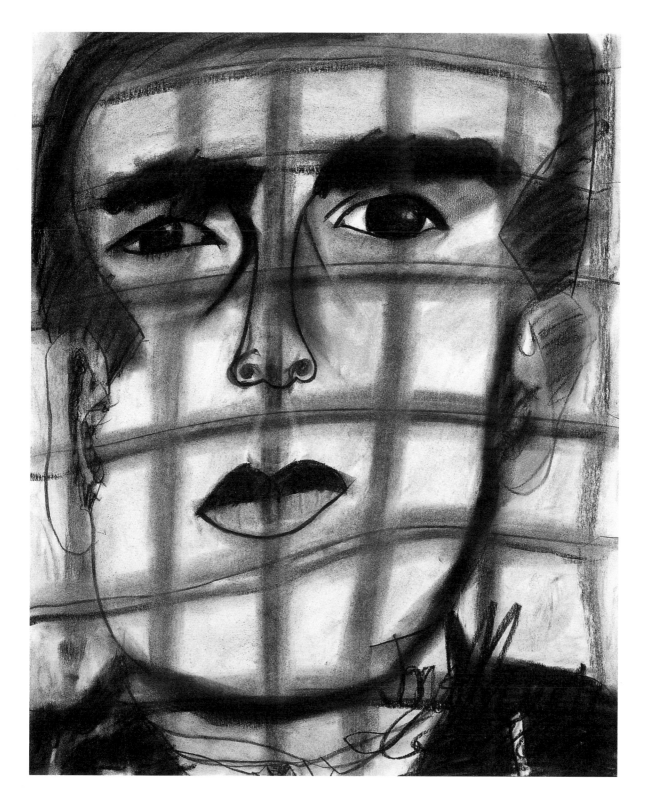

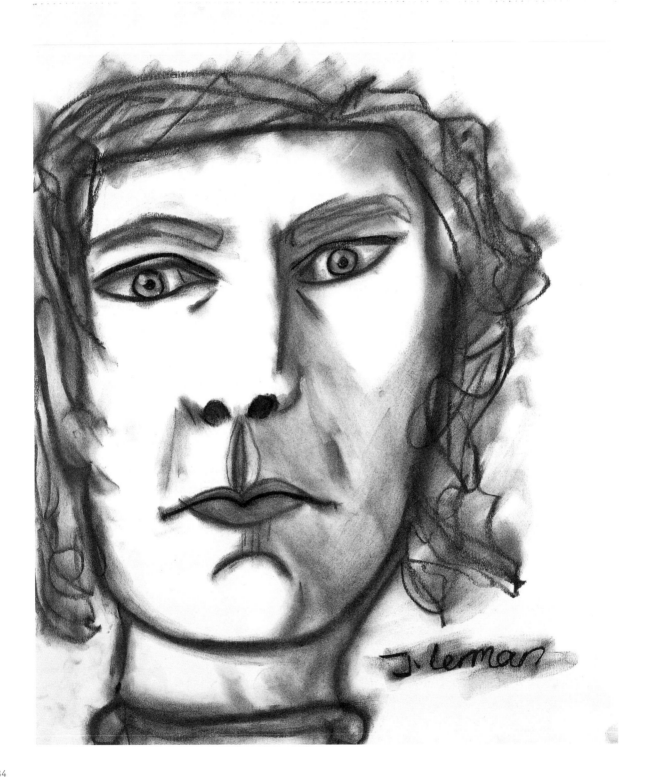

13. 2000 17 × 14 in.

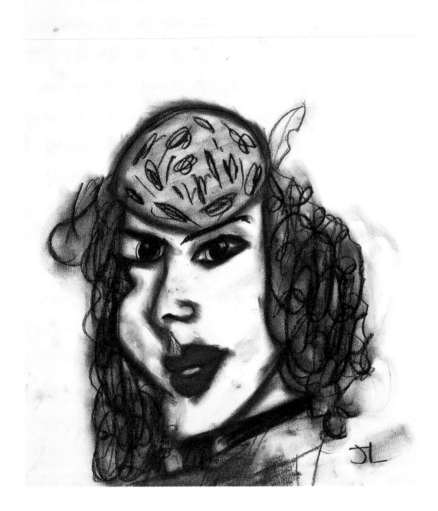

14. 1999 17 × 14 in.

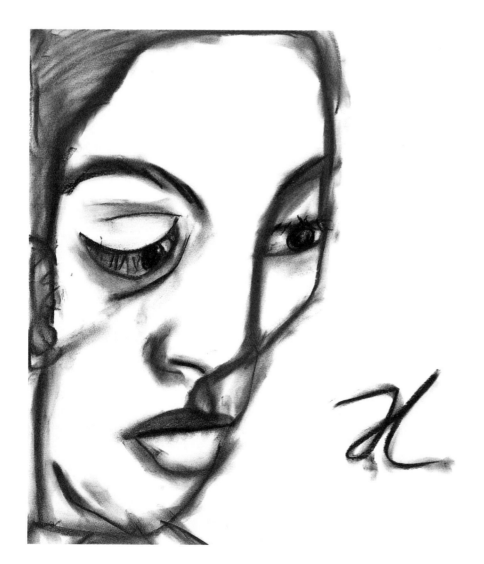

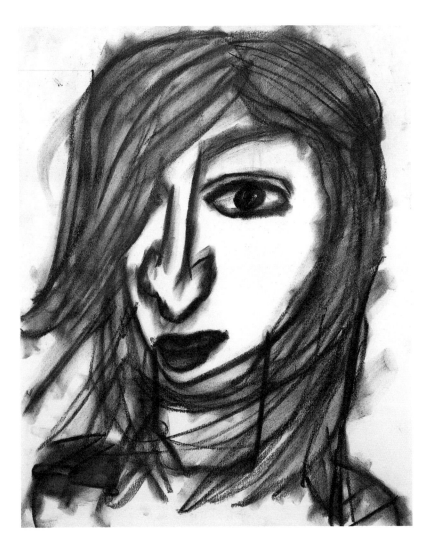

16. 1999 17 × 14 in.

17. 1999 17 × 14 in.

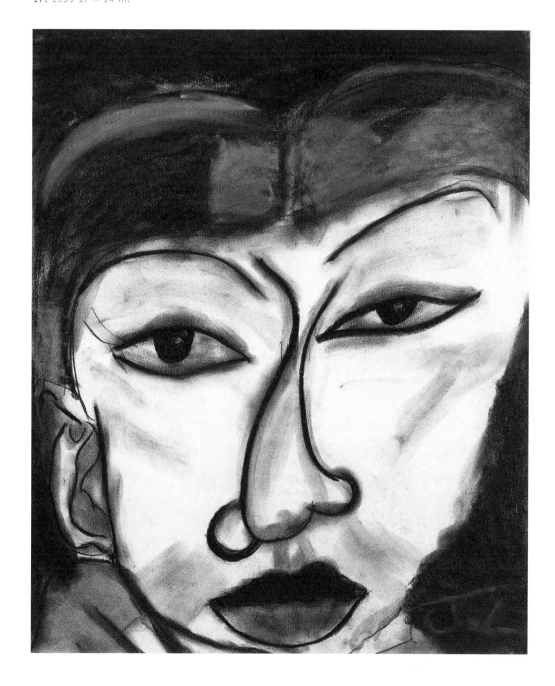

18. 1999 17 × 14 in.

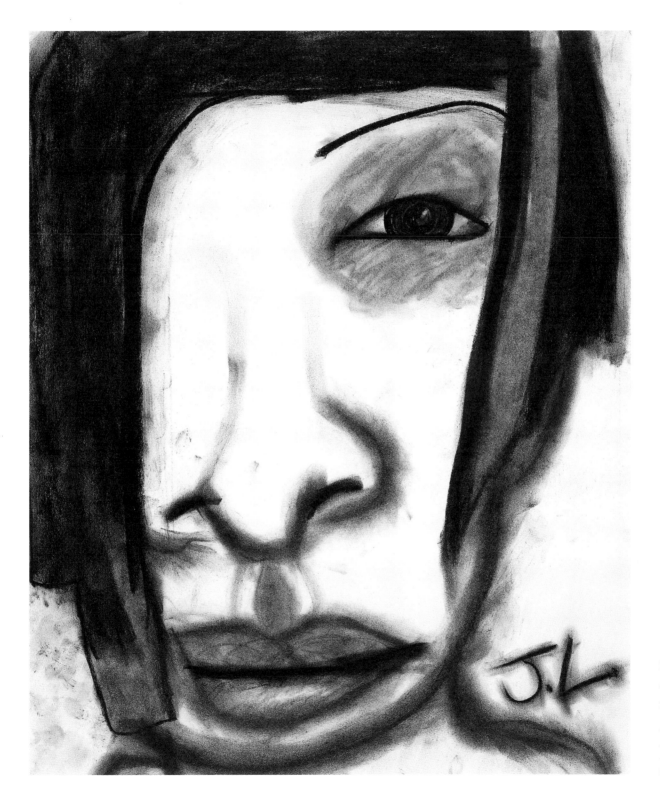

19. 1999 17 × 14 in.

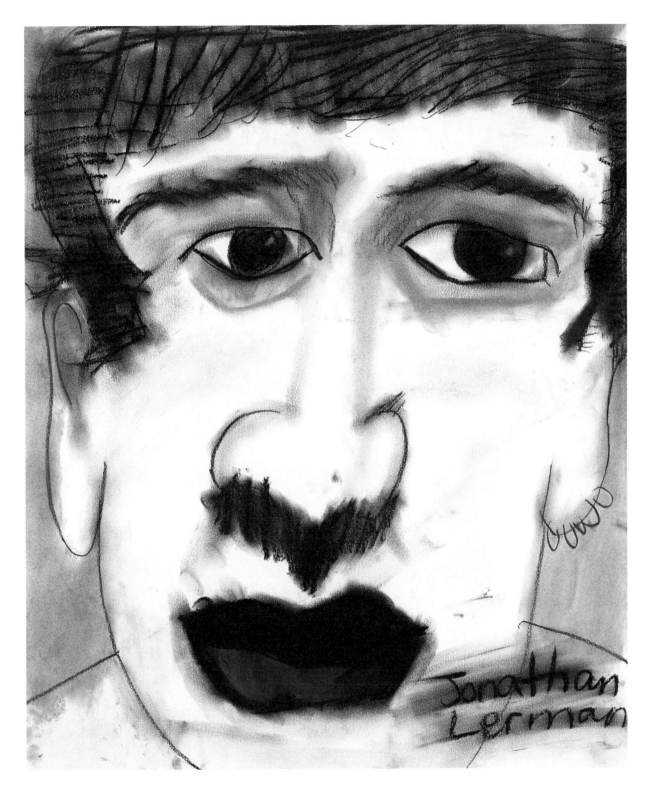

Jonathan Lerman

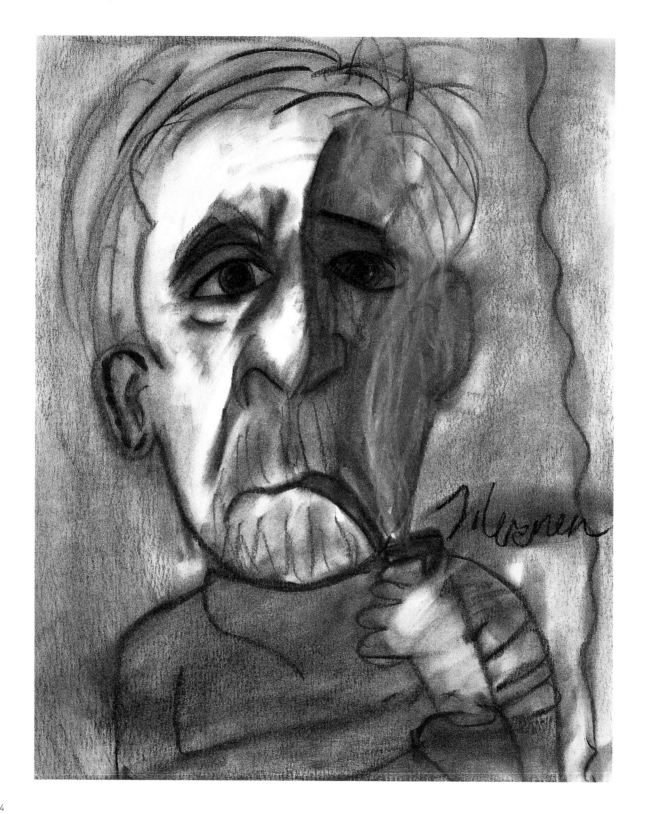

20. 2000 17 × 14 in.

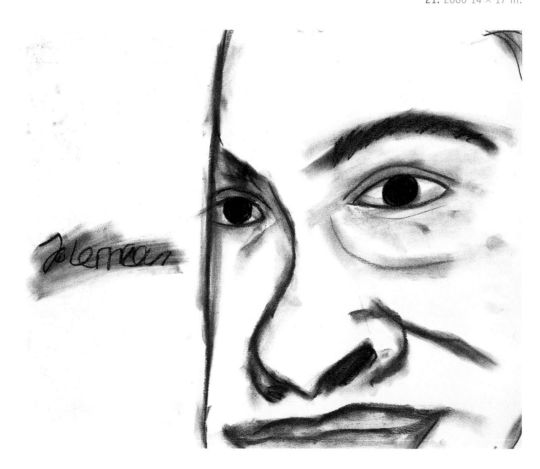

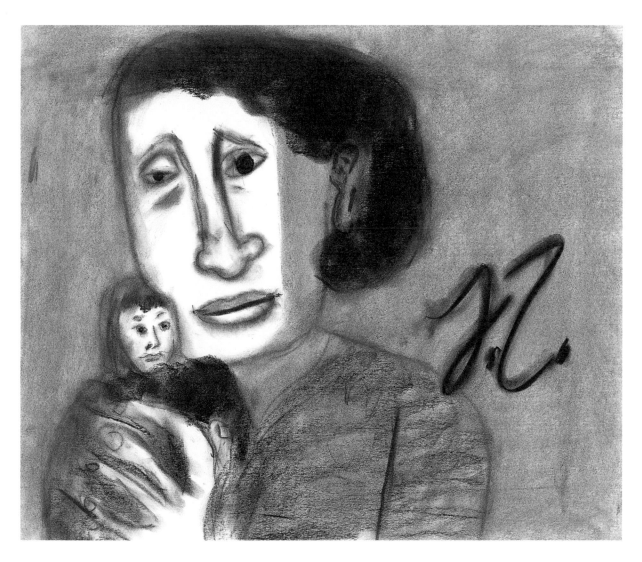

22. 1999 14 × 17 in.

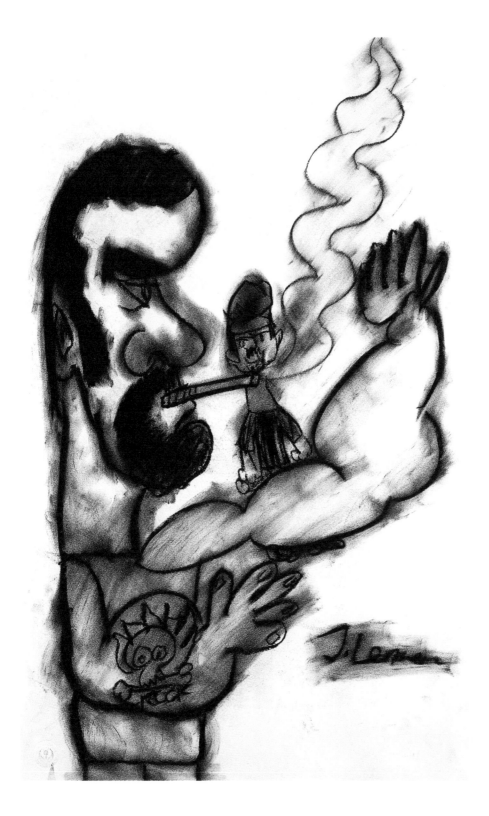

24. 2000 24 × 15 in.

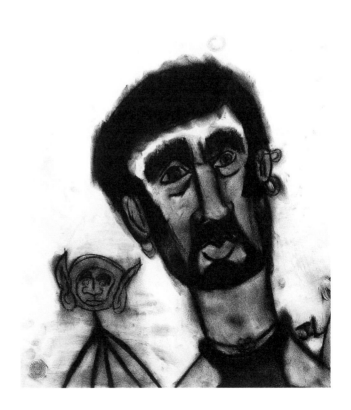

25. 2000 24 × 15 in.

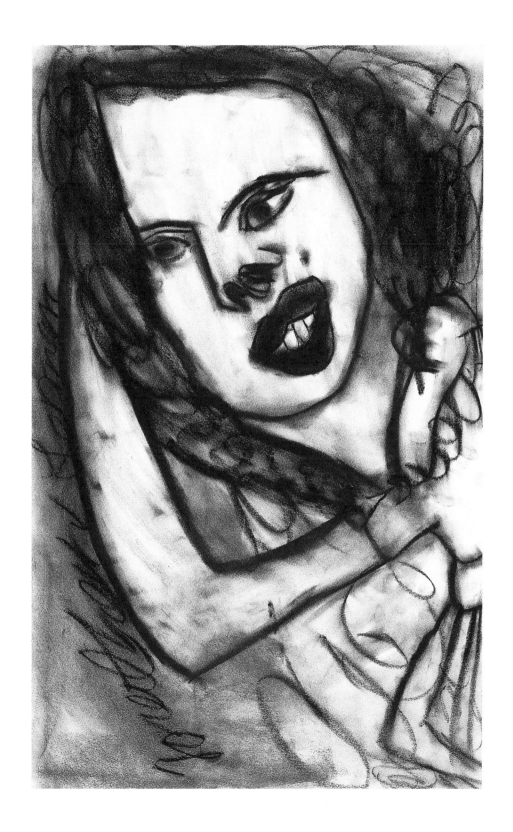

26. 2000 24 × 15 in.

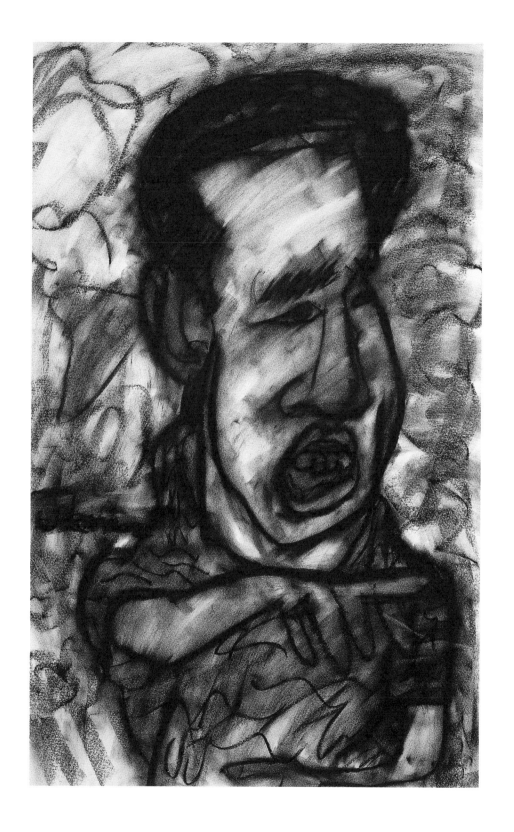

"The Man"

Who is the Man? Surely no single person, for the portraits in this remarkable series are all different. Yet they seem to occupy the same psychic and creative place. They seem to be totems, and around them swirl animal images and figures of fantasy without any regard to a unified visual field. What appears to be a cartoon image of the Chicago Bulls logo shows up repeatedly, as does a basketball, suggesting that these drawings incorporate wish fulfillment. That may be the source of their energy, for the Man appears to be a powerful and even transgressive figure. Things happen around him that perhaps ought not to, like smoking. And the signs that appear with him suggest an apocalypse: "The God is wrong," and "Flame of the burning."

Yet the energy of this series is generative, not transgressive. It seems to me that Lerman has used the central figure as an occasion to experiment, or at least to import figures into the space and to treat it two dimensionally. So a bird can perch on cigar smoke. Why not? It is easy to suggest a kinship to Surrealism and the odd events that could take place in a single picture plane. But Lerman's drawings of the Man are not unified in that way. They are not meant to be single pictures or to carry a psychological subtext. The elements are often discontinuous, so the drawings provide the glimpse of a process of visual association unfolding over time. The Man seems to inspire this process but not provide the key to it. We could hunt for symbols, but behind them there would be no meanings. As Lerman reminds us without meaning to, "The God is wrong." LR

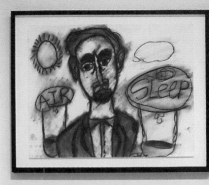

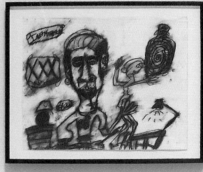

27. Installation at K.S. Art, solo exhibition, 2001

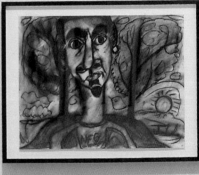

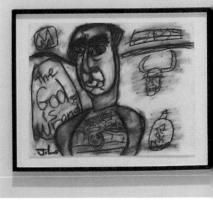

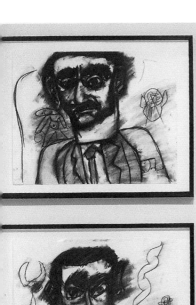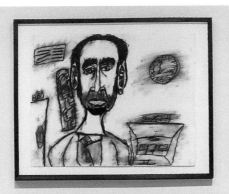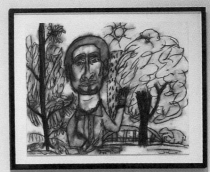
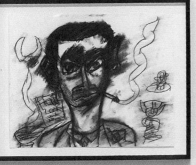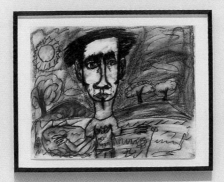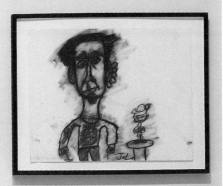
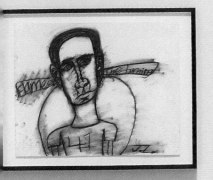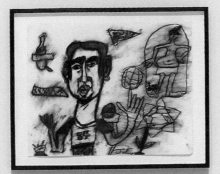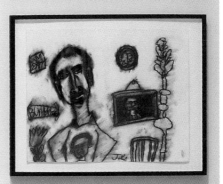
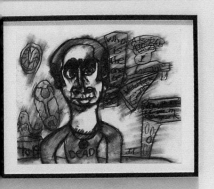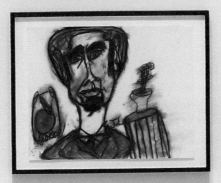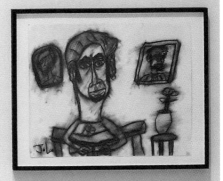

28. 2001 19 × 24 in.

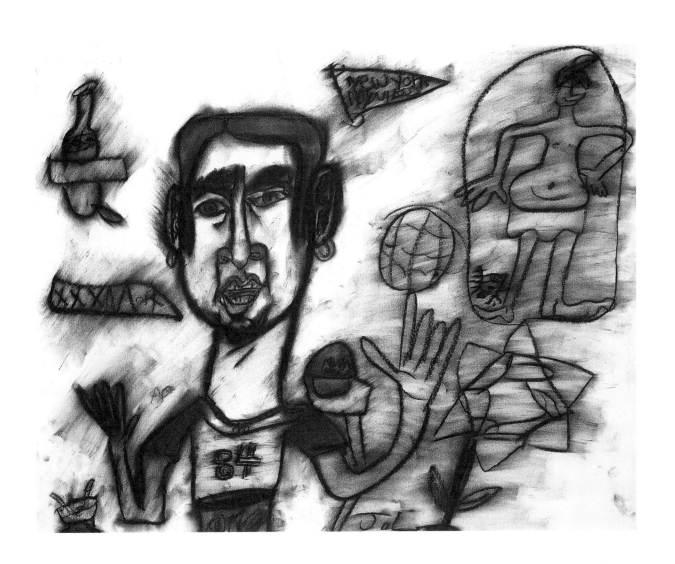

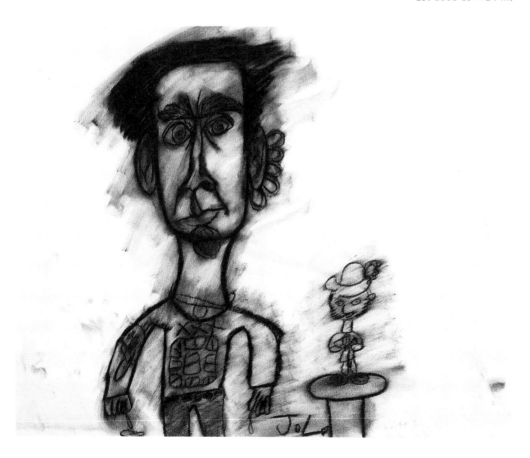

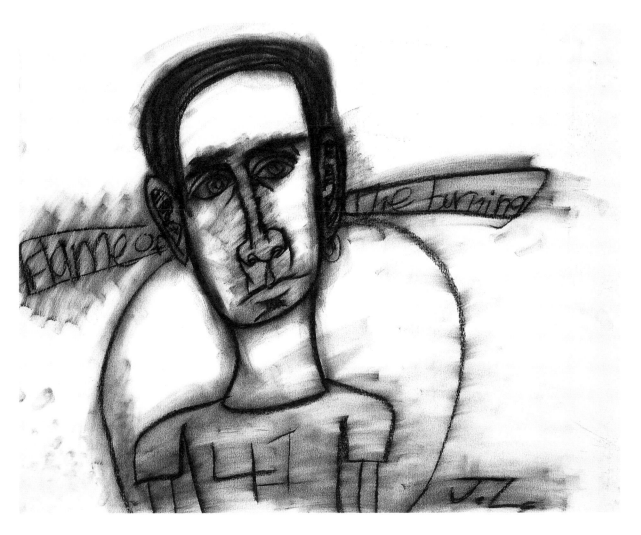

30. 2001 19 × 24 in.

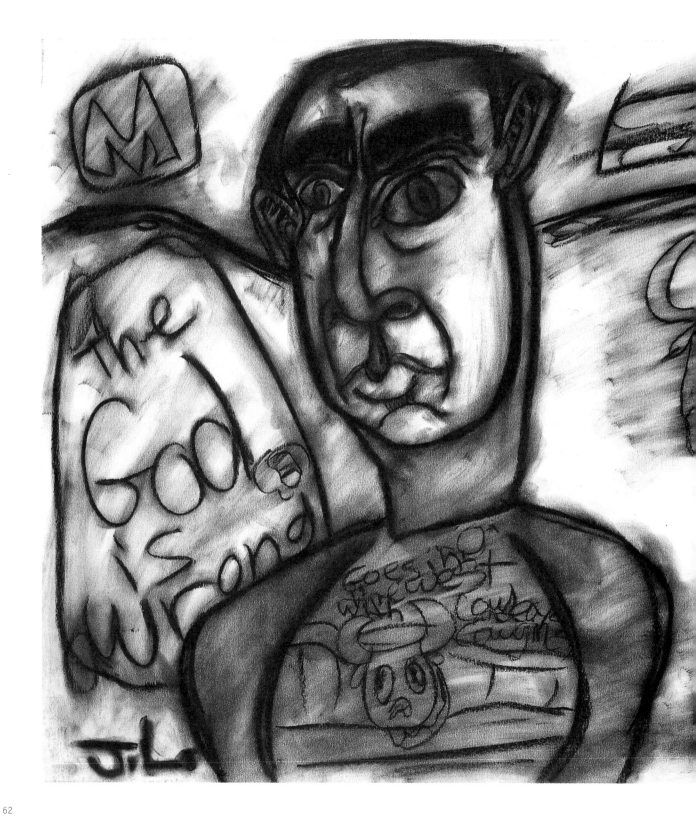

31. 2001 19 × 24 in.

32. 2002 19 × 24 in.

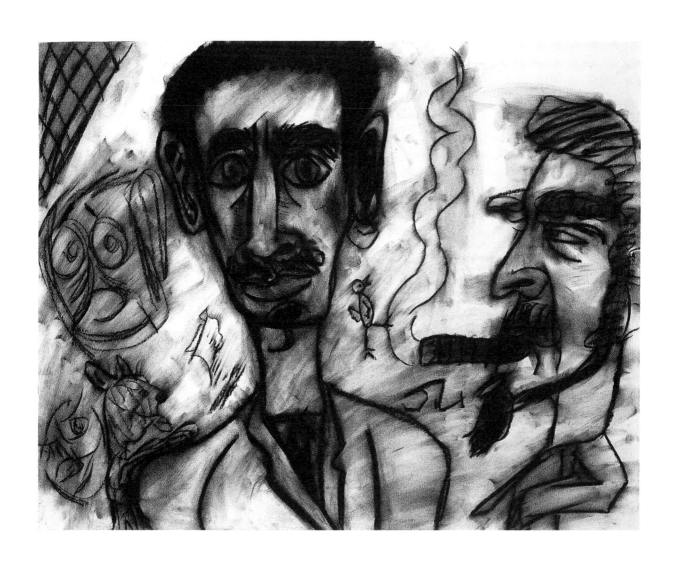

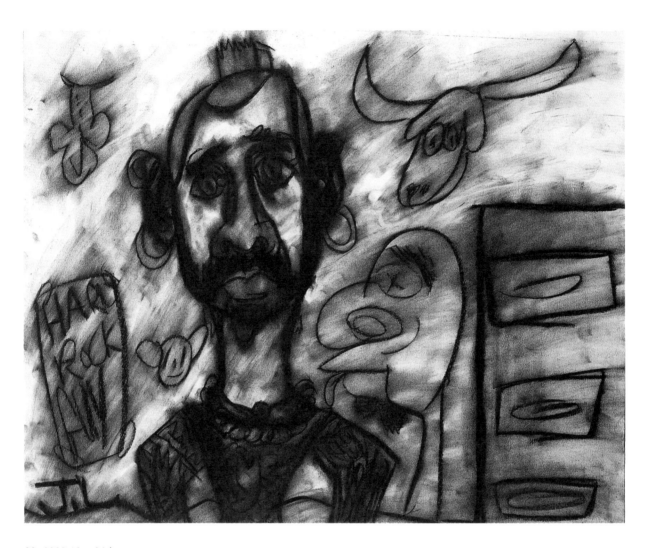

33. 2002 19 × 24 in.

34. 2002 19 × 24 in.

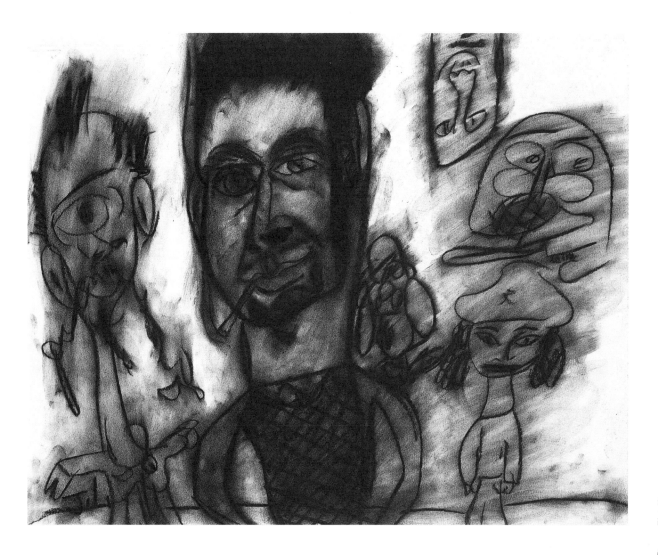

35. 2002 19 × 24 in.

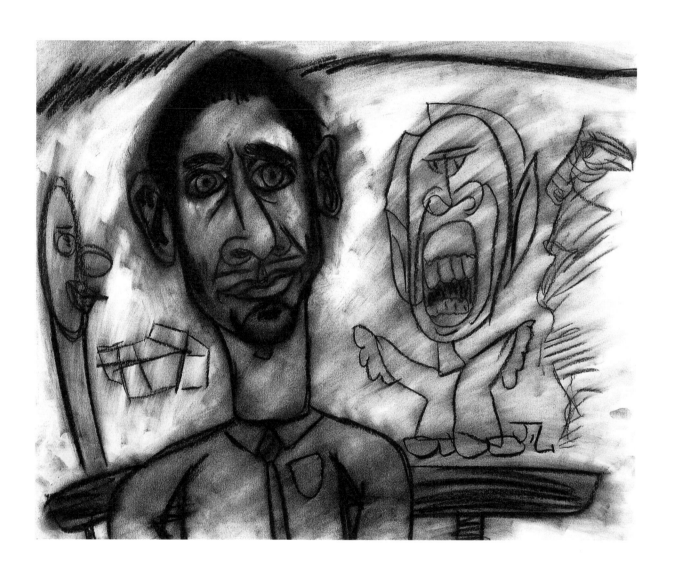

"I Love Rock and Roll"

It was the singer Joan Jett who sang "I love rock and roll," and we had to believe it. But if rock and roll hadn't been invented, Jonathan Lerman would have made it up. He has translated his infatuation for the music into images of the people who make it. Rock and roll is exactly the right subject for him and the wrong one, too, at least in conventional terms. Rock is full frontal presentation, and the performers are all attitude. Both of these suit him. A commentator more familiar with contemporary grunge bands might be able to identify the groups he likes to draw. Knowing Lerman's fascination with Kurt Cobain, I suspect Nirvana may be the model, but it doesn't matter. He distills the lugubrious posturing of the bands and their stage anguish. Tying the compositions together is another matter. Without having mastered depth, Lerman never has quite enough room, no matter how empty the stage. And those guitars! He seems to know where he wants the hands to be and bends the guitar to make them fit. On the other hand, the rubber guitar is the perfect metaphor for musical virtuosity.

An additional word needs to said about Lerman's portrait of Bob Dylan. Most likely working from a photograph, Lerman has identified in an instant aspects that convey Dylan's stage personality. Lerman's quick and unfettered hand renders the disorder of Dylan's physical appearance even as his deliberate foreshortening of the mouth and chin identifies a feral quality that has become more pronounced as the musician has grown older. This borders on simple caricature except for Lerman's ability to bring into focus what lies hidden in—not behind—appearances. LR

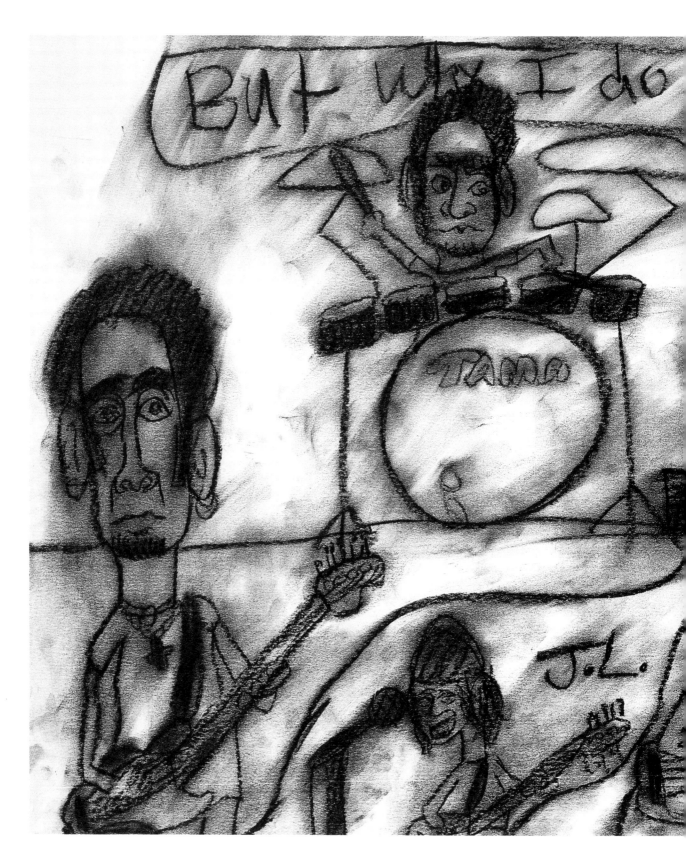

36. 2001 14 × 17 in.

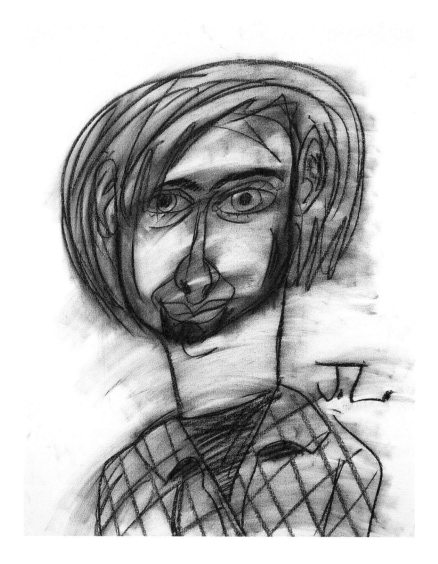

37. 2002 24 × 19 in.

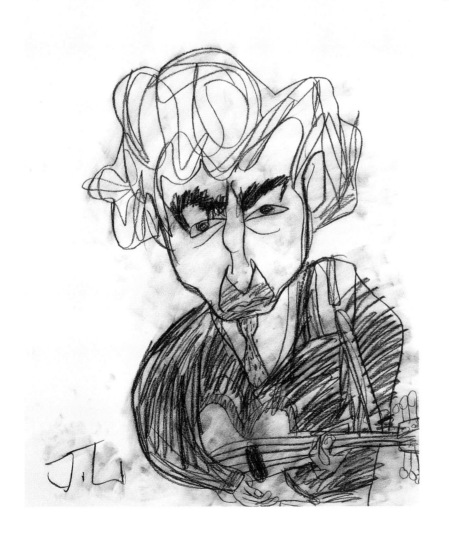

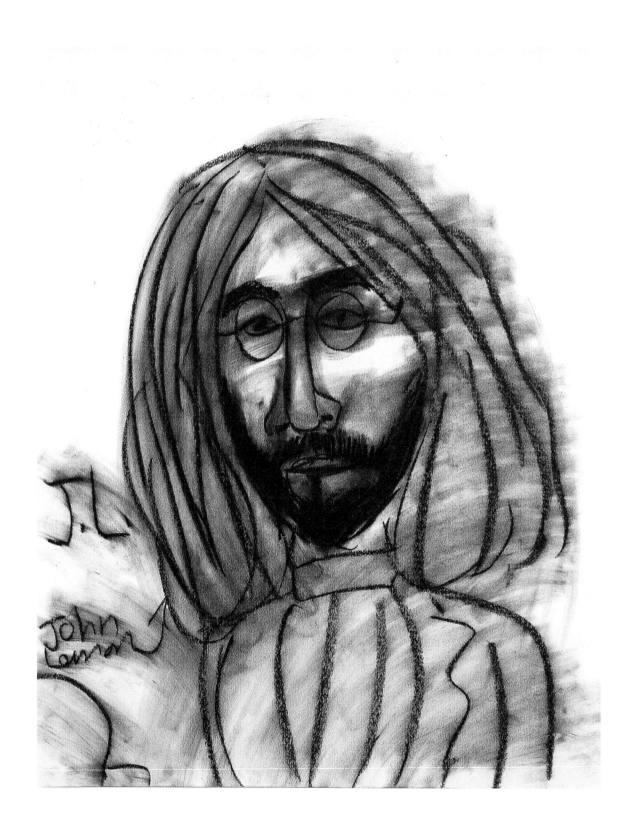

39. 2001 24 × 19 in.

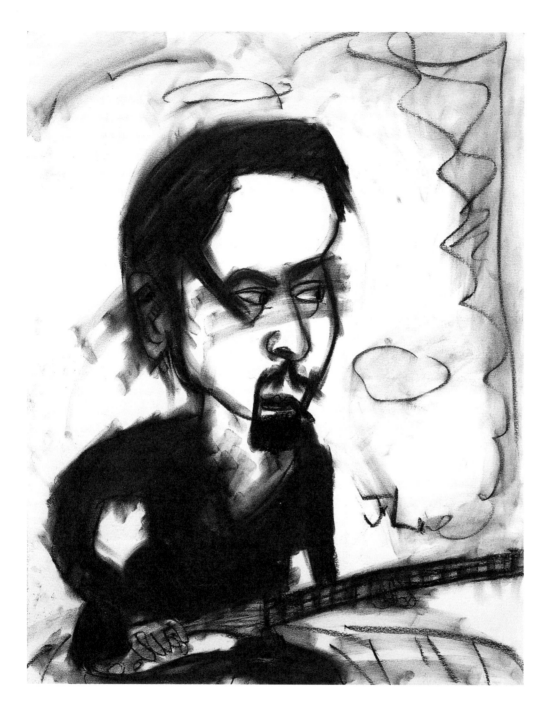

40. 2001 24 × 19 in.

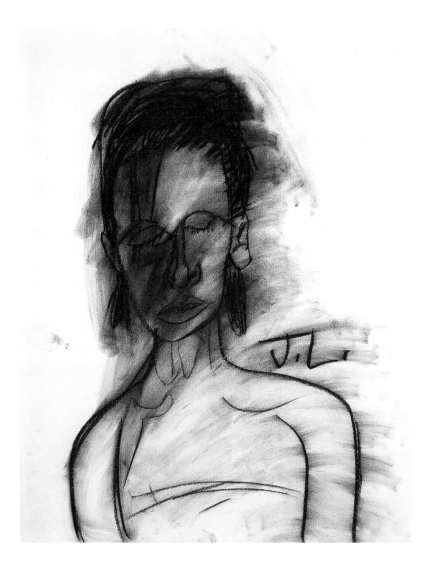

42. 2001 19 × 24 in.

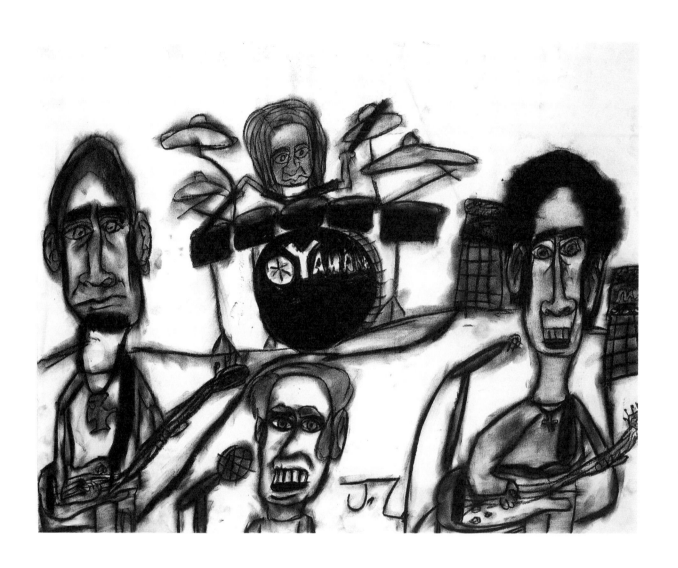

Men and Women, Alone and Together

The autistic author Temple Grandin has insisted that there is a barrier to feeling in people with autism—an inability to intuit other people's states of mind and perhaps a general lack of affection, based on an inability to recognize other people as, well, other people. In her words, it is like being "an anthropologist on Mars." Jonathan Lerman's drawings suggest a more dynamic relationship.

To my mind, the most engaging and expressive of his pictures all involve women. While many of the male portraits strike me as almost exclusively visual, his women seem to embody another dimension of emotional experience, with a richer repertoire of expressions and gestures. I am thinking in particular of he image of the blond woman—she looks a bit like Hedy Lamarr or some other movie star from the 1940s—whose hair allows us to see only one wide, wild eye and whose mouth seems poised between a greeting like "Dahling" and a cry. It may not be useful to speculate on Lerman's maternal or sexual feelings, but the pull of these images toward the physical presence of the subject seems undeniable.

This pull appears more clearly in the portraits of couples. As Lerman has moved into adolescence, his interest in men and women together has burgeoned. Regardless of his models, he always attempts first to work out the physical relation of the couple and, along with it, the emotional aspects of their interaction. This process has yielded some of his most complex pictures. Clearly these ensembles are not as deliberately psychological as, say, a family portrait by Edgar Degas, for instance, but the center of emotion and consciousness is almost always the women. Either they occupy the central position in the image or they give it the emotional energy, an energy that can border on the erotic. LR

43. 2001 24 × 19 in.

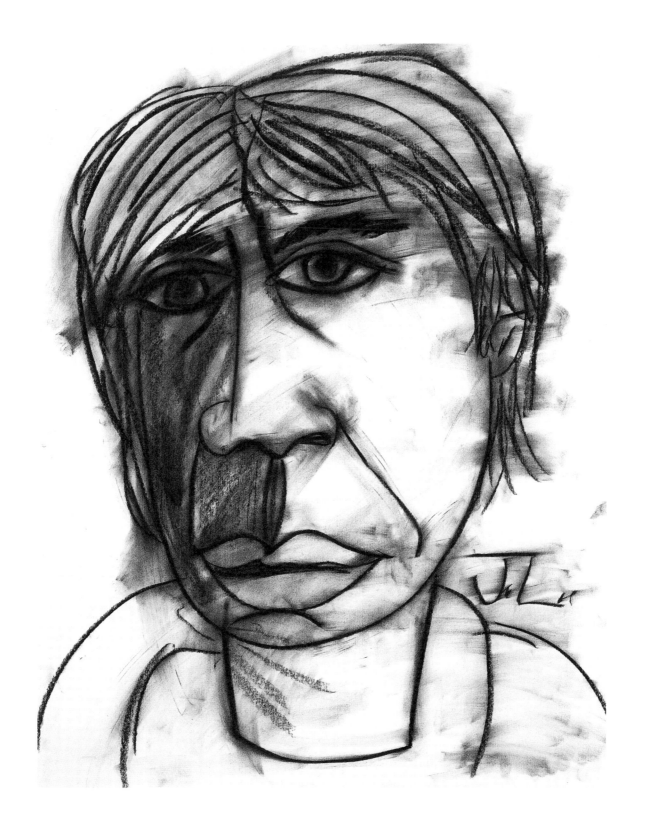

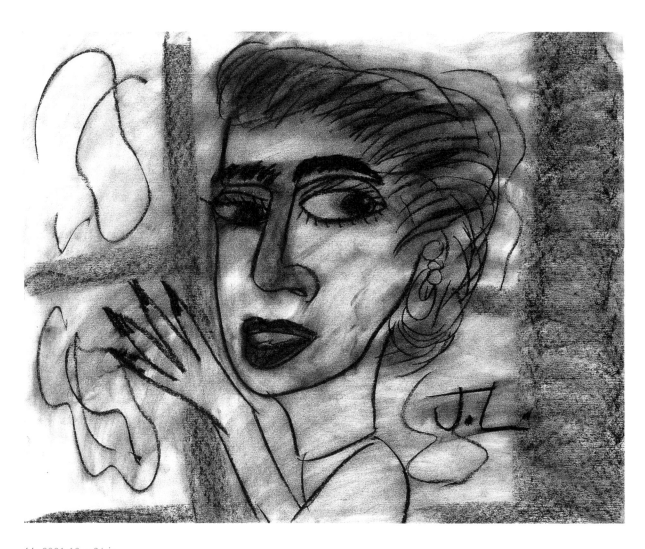

44. 2001 19 × 24 in.

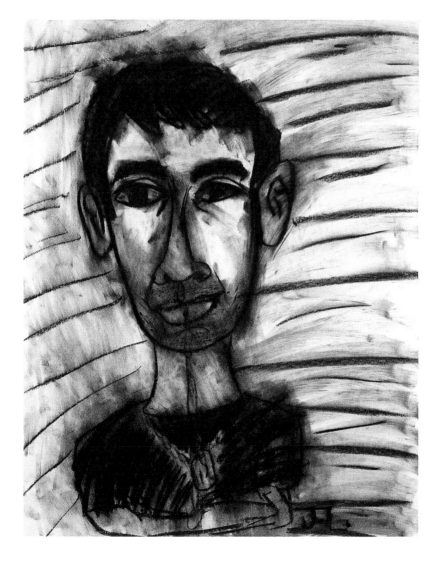

45. 2001 24 × 19 in.

46. 2001 24 × 19 in.

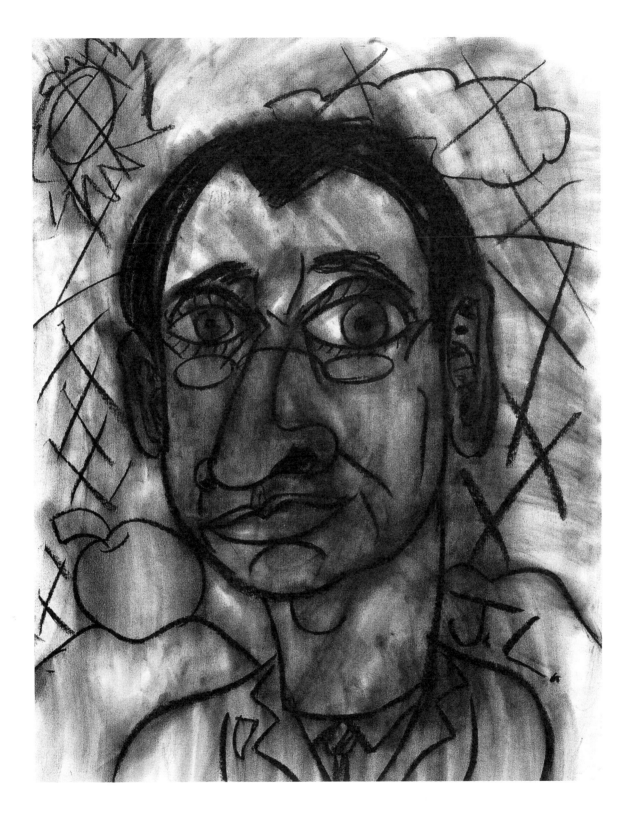

47. 2001 24 × 19 in.

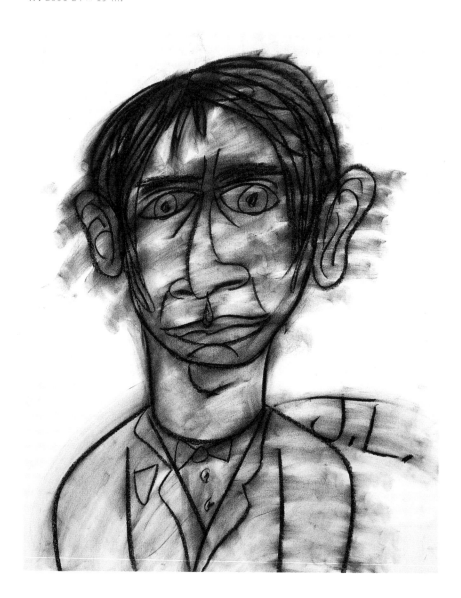

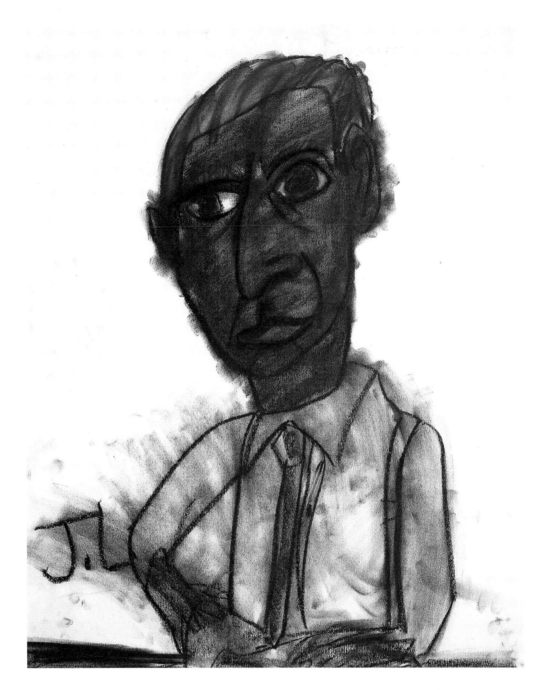

48. 2001 24 × 19 in.

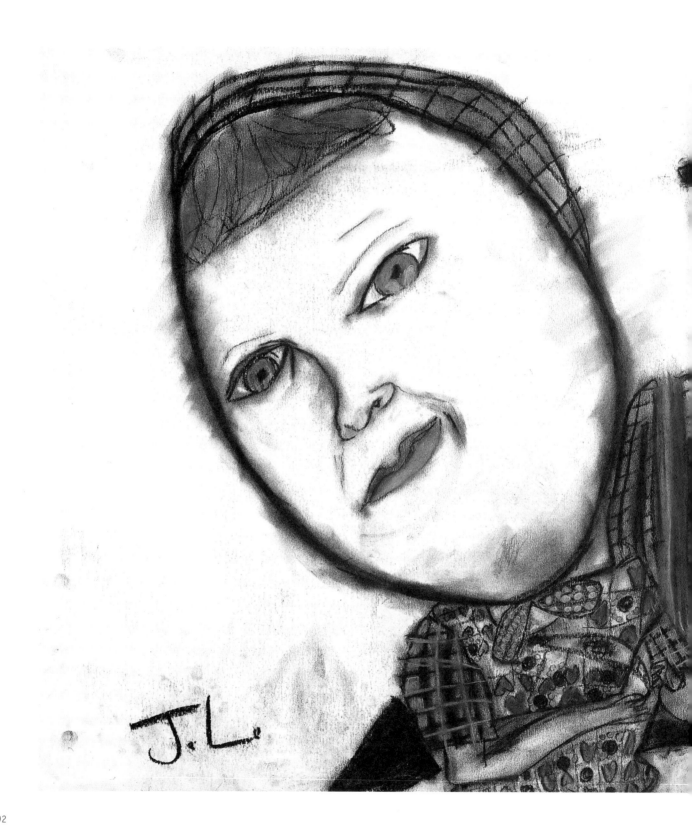

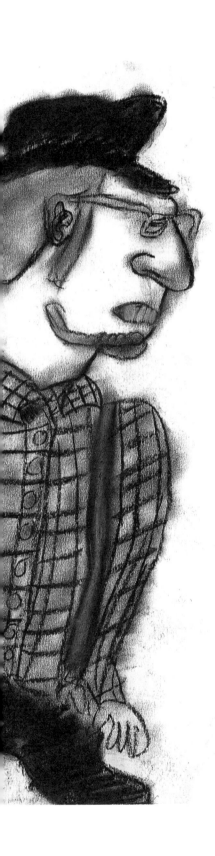

49. 2001 19 × 24 in.

50. 2002 24 × 19 in.

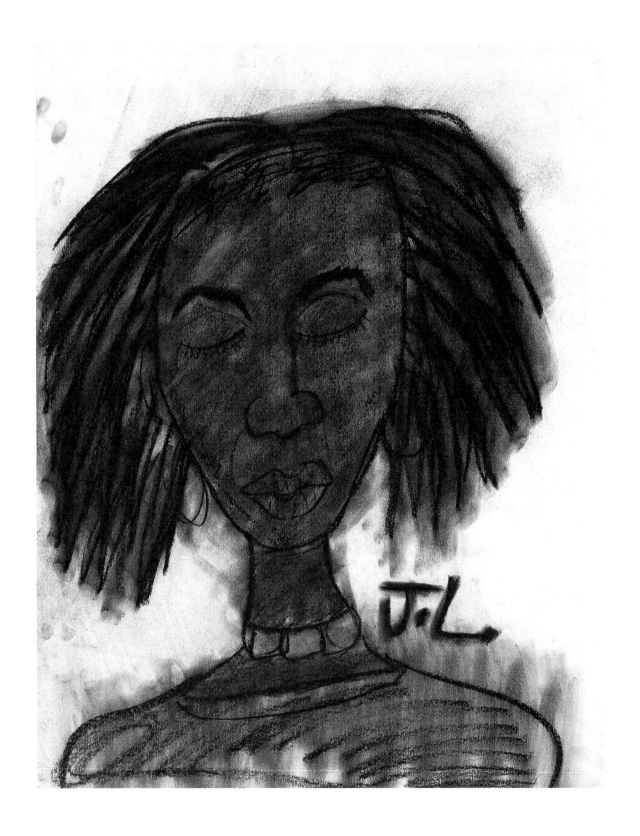

51. 2002 24 × 19 in.

52. 2002 24 × 19 in.

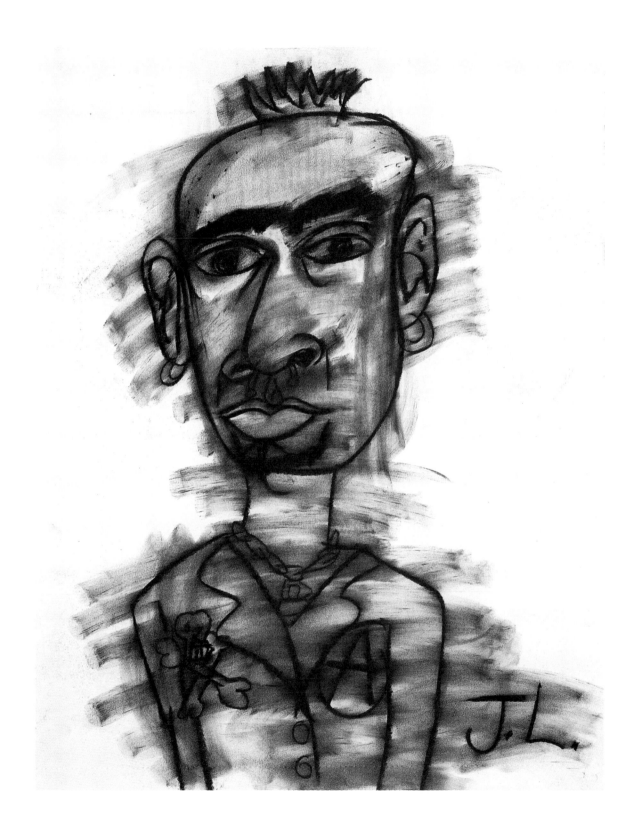

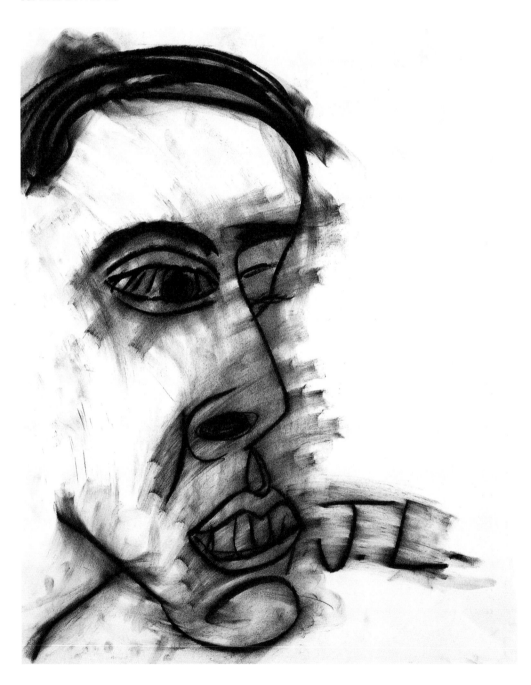

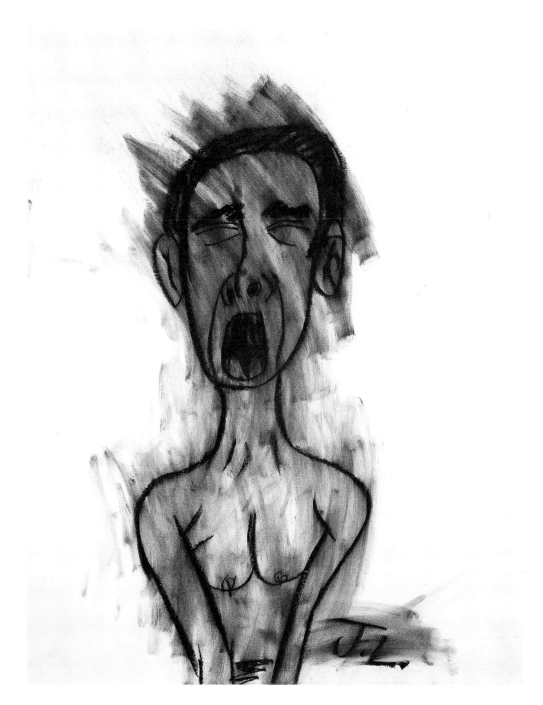

54. 2002 24 × 19 in.

55. 2002 24 × 19 in.

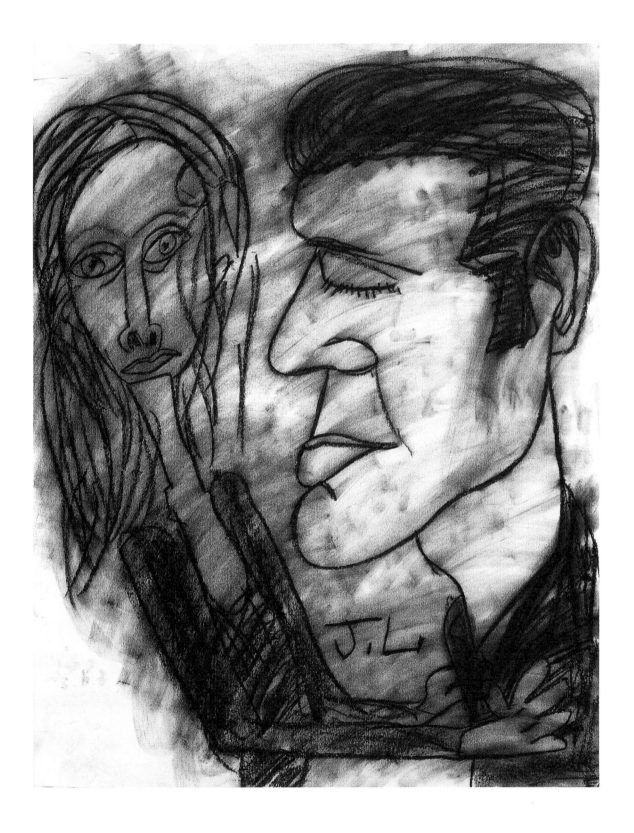

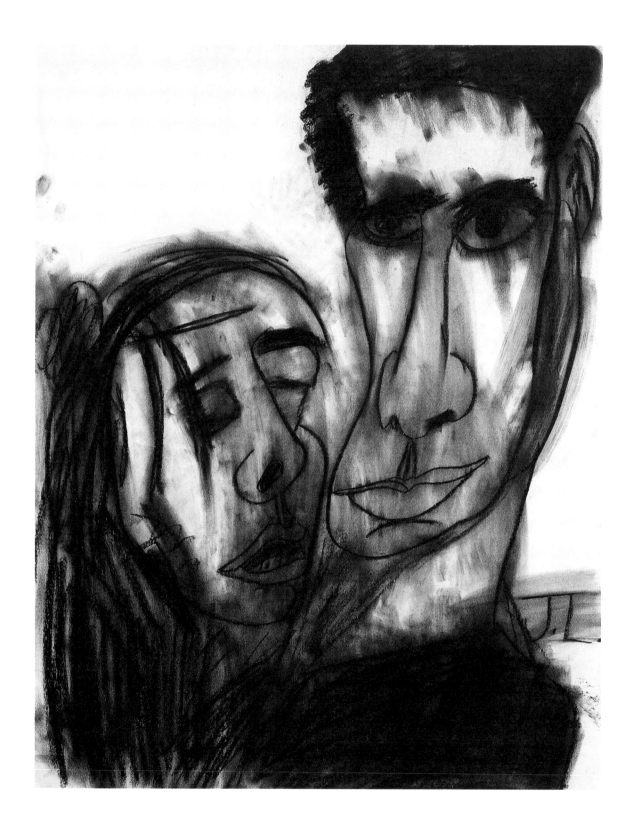

56. 2002 24 × 19 in.

57. 2002 24 × 19 in.

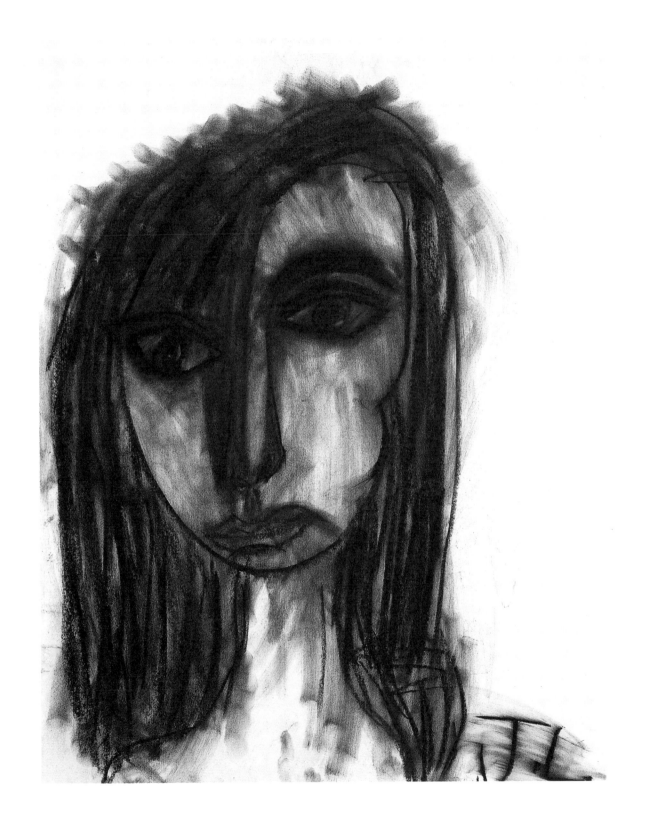

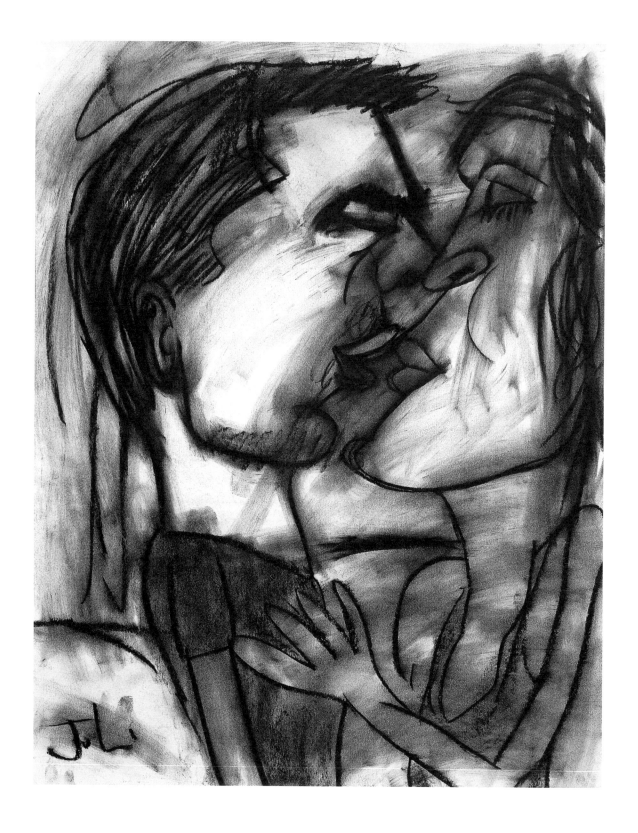

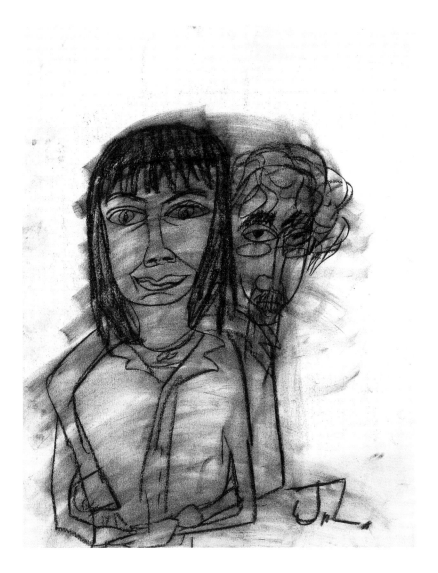

59. 2002 24 × 19 in.

58. 2002 24 × 19 in.

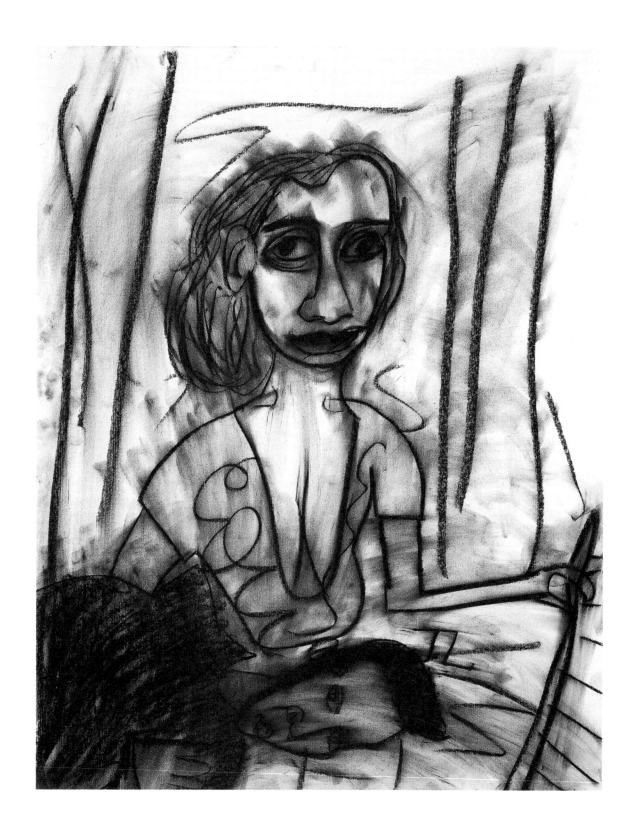

60. 2002 24 × 19 in.

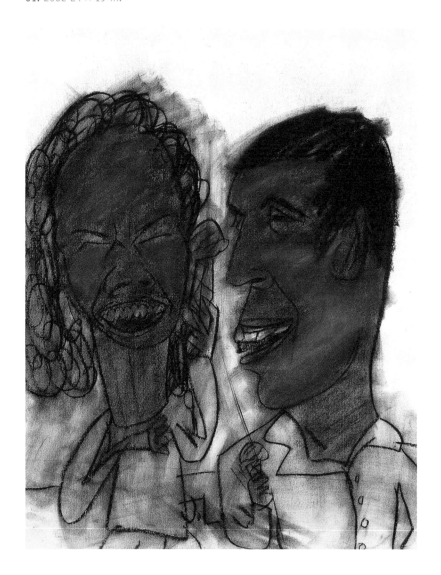

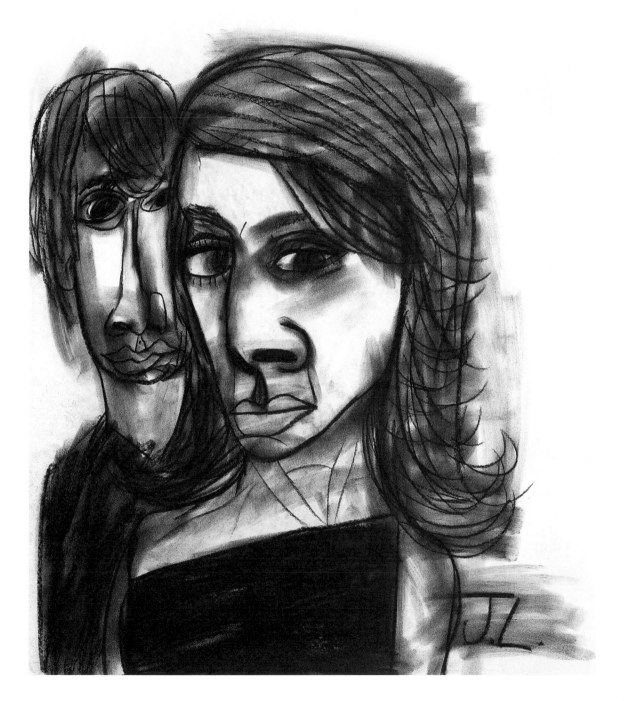

63. 2002 24 × 19 in.

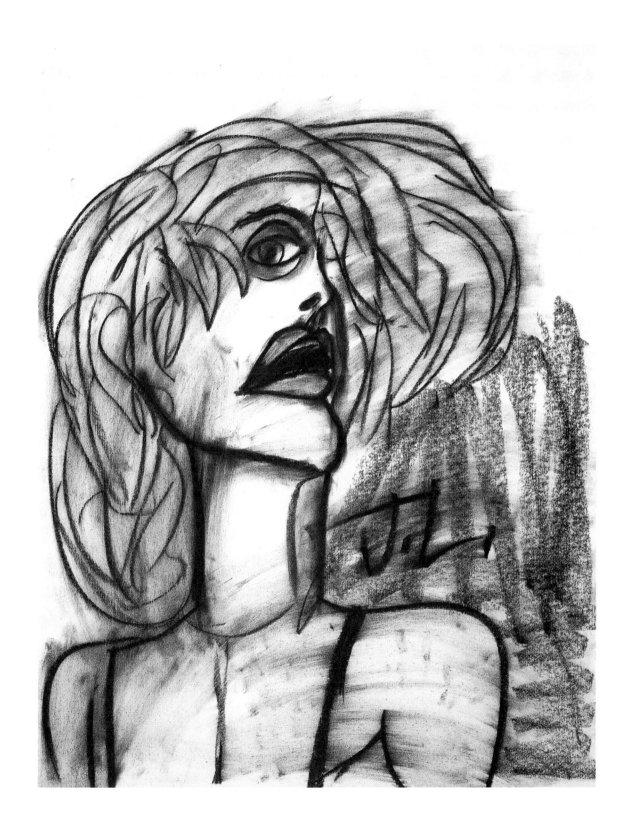

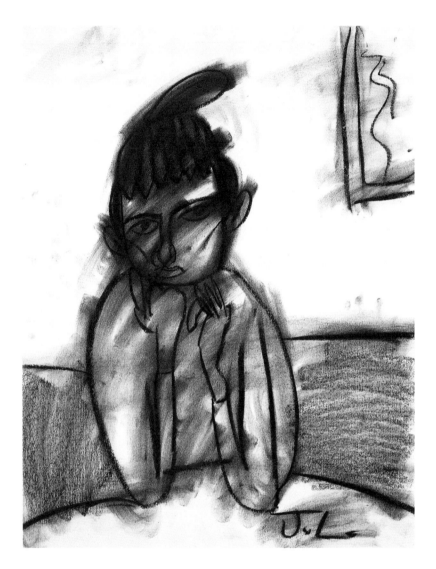

64. 2002 24 × 19 in.

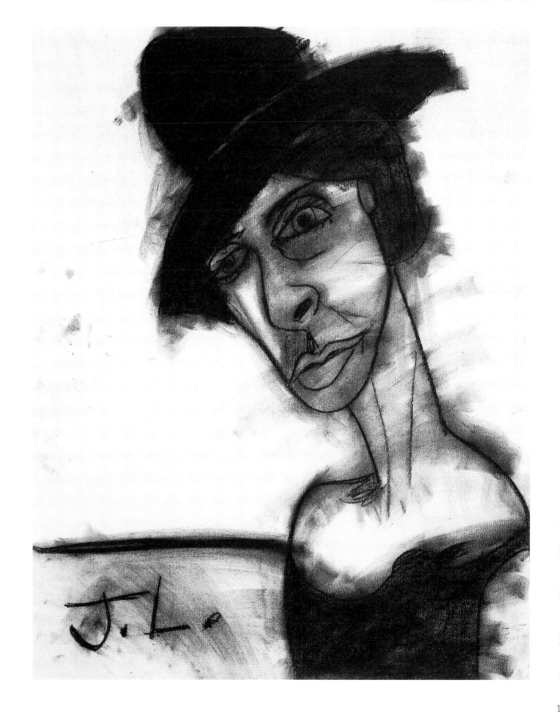

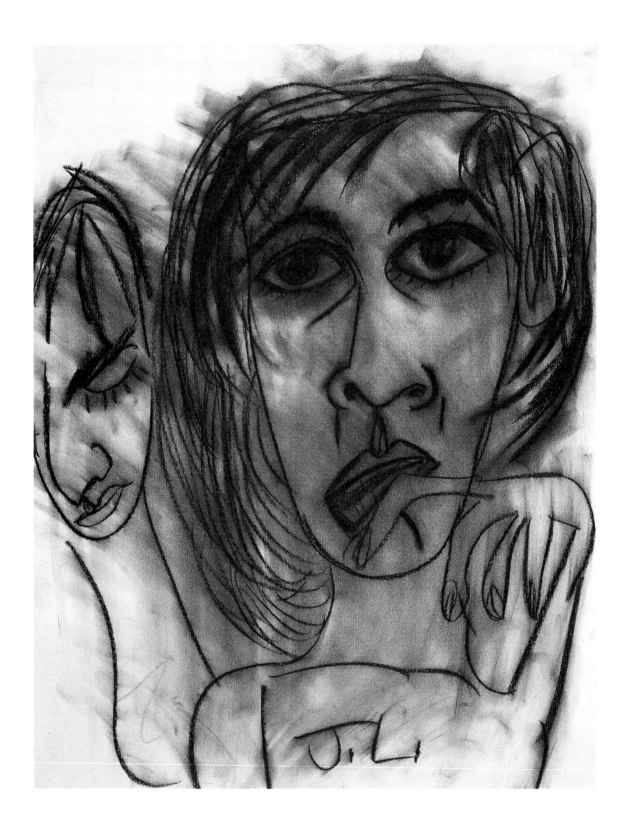

66. 2002 24 × 19 in.

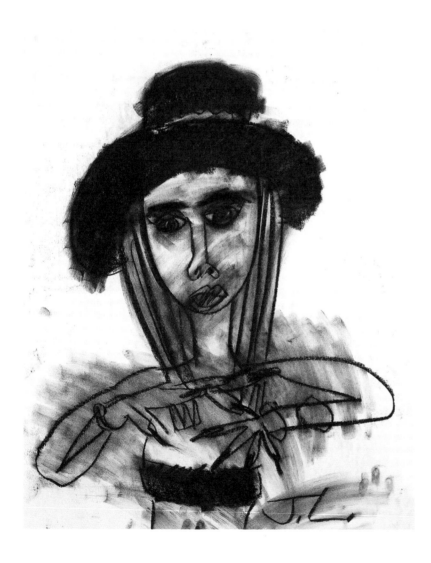

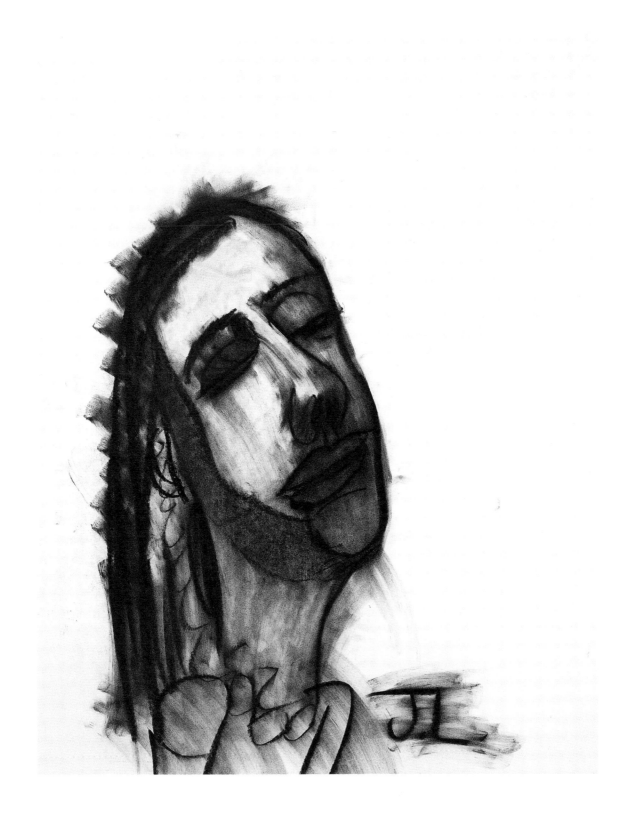

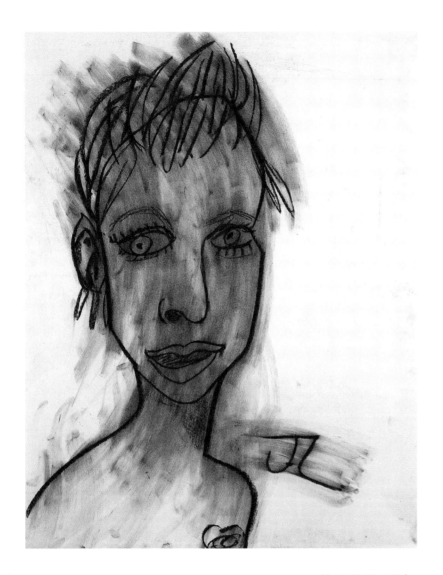

69. 2002 24 × 19 in.

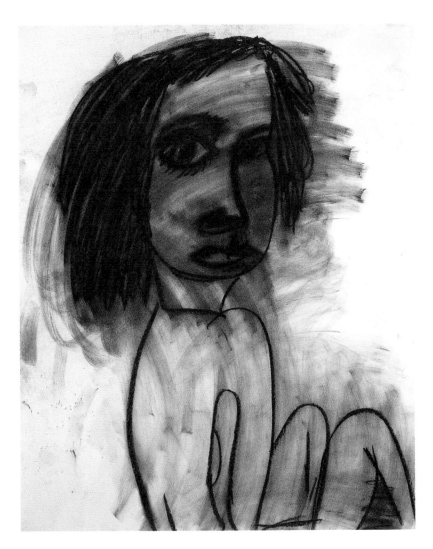

70. 2002 24 × 19 in.

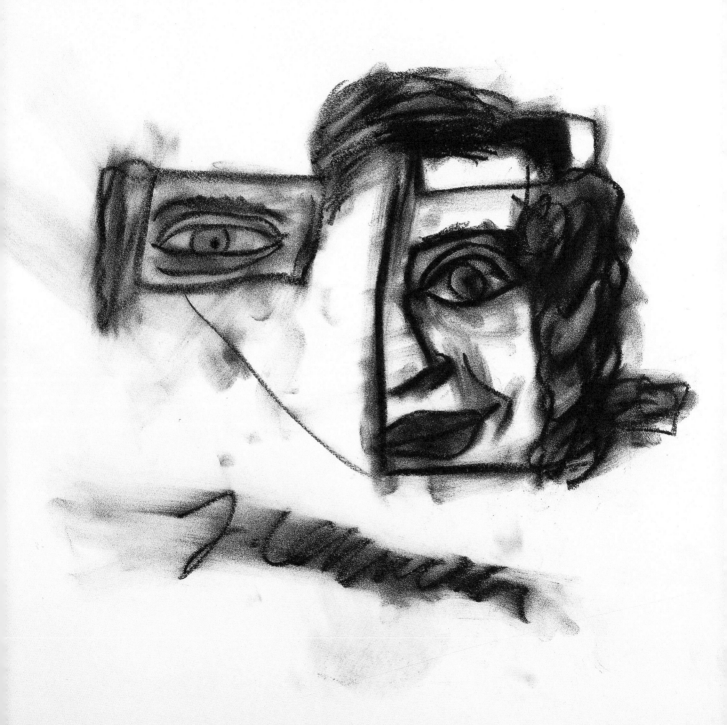

Not all flowers grow straight and true,
And
Yet
They are all, beautiful.

Afterword

Caren and Alan Lerman

When Jonathan was born, we looked into his eyes and knew that life didn't get any better. He was a perfect angel, beautiful in every way. As we held him closely, we pondered a wonderful life ahead.

The love we feel for Jonathan has surpassed any love we have ever known. It has a depth beyond words. The first time he smiled, at four months, was magical. We cherished each passing day as we watched him grow. But around Jonathan's second birthday, he slowly began to slip away. The cheerful alert boy was vanishing. We would call out his name, and he wouldn't respond. The few words he once knew were gone. He would laugh often, although no one else was laughing. He would lie against the wall for comfort and tear his hair out in clumps when he was upset. And although we longed to comfort him, he resisted our attempts.

In the eleven years since Jonathan's diagnosis, we have come to know autism intimately. The day our family was told why our little boy was this way, we felt our whole world shatter into a million pieces. We were devastated, experiencing a pain that defies description. Our hopes and dreams for his normal, wonderful life were dashed in an instant.

As we would learn, Jonathan's course was typical. Autism usually appears during the first three years of

Opposite page: 2001 24 × 15 in.

life. It is a neurological disorder that interferes with the normal development of the brain in the areas of social interaction and communication. The ability to express, to understand, and to respond appropriately to all forms of language—verbal and nonverbal—are severely affected. About half of all people with autism have some degree of mental retardation. The disorder makes it hard for Jonathan to communicate with others and to fit in with his peer group. This leads to behavioral problems, unusual attachment to objects, and resistance to change. He avoids eye contact and has no real fear of danger. Jonathan's autism stunts his ability to express what makes him cry, what makes him smile, what makes him laugh. He knows he is different, and he struggles to fit in.

It has long been widely believed that children with autism do not comprehend the emotional states of others and, indeed, may be extremely limited in their ability to understand or experience their own emotional states. For many years, we assumed that it was so for Jonathan.

Then, one day, when Jonathan was ten years old, we received a phone call. Whenever he was away at school, we always expected the phone to ring. Usually, it was because his behavior was so inappropriate or out of control that his teachers could not handle him. This call, however, was different.

"You have got to come down here and see what Jonathan is doing," Eryn, his aide, said.

"What?" we asked. "Holding the other kids hostage?"

"No, it's really wonderful," she responded excitedly.

"He's drawing—beautifully. You've got to come and see this, now!"

We drove to the school, where we looked at Jonathan's work in amazement. A chance encounter with charcoal and pastels revealed the inner thoughts and feelings of a child whose emotions we could only speculate about until then. In that instant, we went from knowing that we had a significantly handicapped child to realizing that we had an extraordinarily gifted child.

Jonathan's talent emerged soon after a death in the family. Contrary to what we expected, Jonathan was, in fact, profoundly affected. But we learned this only later, through his drawings. One of them was a self-portrait of a bruised boy with tremendous tears. We realized, with a strange mixture of sadness and joy, that Jonathan was grieving just as we were. He knew, he felt, and he could express his feelings—just not in the ways most of us do.

It was during this painful period that Jonathan quickly went from mildly doodling cartoonlike figures, to creating skilled, expressive charcoal drawings that offer us a window into his heart. He brings us to the core of his being and shows us the anguish and triumphs he experiences. People come alive in his drawings, their emotional expressions delineated by his bold beautiful lines. Jonathan's portraits have an intensity that is extraordinary. His observations are so acute, telling us he knows far more than we realize and allowing us to confront the lonely isolated world he inhabits. We no longer have to guess if he feels the way

we do—we now know he feels very deeply and is keenly aware of the world around him.

What does this talent mean in the larger scheme of things? We believe that Jonathan, through his work, teaches us that we must open our eyes to the world of people with autism. He is helping us expand our knowledge and transcend our beliefs about their perceived limitations. Yes, Jonathan is only one person with autism. And, yes, he is a savant, a trait that is extremely rare among the autistic. Some may believe that he is simply a rare exception, but we don't think so. Jonathan may be only one person with autism, but we have no way of knowing that other people with autism do not experience a similar degree of emotional connection and simply lack the talents to express it, to communicate what they know and feel. What would Jonathan be like today had he never happened upon those pastels and charcoals? And how would any of us, who know and love him, see him? Or see ourselves?

To understand, to know, and to love a child with autism takes a belief: that autistic children have many abilities that must be nurtured once we recognize and discover them. It also takes love. In Jonathan's case, the love of parents, teachers, and friends gave him the window of opportunity he needed to find a way to communicate.

When we believe in and love someone with autism, it brings us hope. Jonathan brings hope to all of us who struggle to express ourselves and realize our talents despite our limitations. To us, Jonathan is a daily reminder of the hope and belief that life does offer miracles, giving us strength when we are completely drained.

Jonathan's art speaks to us about the loneliness and isolation of those who are different. He has shown us that he feels the same way that we all do. Autistic artists that have come before Jonathan have not focused on the human form or the emotional states of others; consequently, we believed they could not. But Jonathan has shown us that we should not impose limitations on him or others. We are learning so much from him.

Jonathan is much like any typical teenage boy. He wants friends and envisions being part of a rock band. He loves watching *The Simpsons*, playing baseball, and listening to rock music. His favorite group is the Beatles. He longs to be just like the other kids and tries so hard to fit in. He shows an interest in girls, and when one he liked seemed too short, he asked us to please give her a ruler, figuring it would add the desired height. We laughed through our tears.

He came to us recently in despair and said, "Fix my brain. It's broken."

"Jonathan, that is our mission in life," we said. "Although, we love you the way you are." As your name suggests, Jonathan, you are truly a gift from God.

Love, Mom and Dad